IMAGES
of America

SISTERSVILLE AND TYLER COUNTY

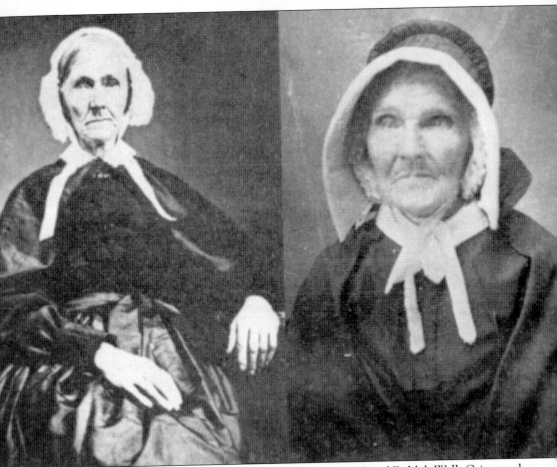

SWEET SISTERS FROM SISTERSVILLE. Sarah Wells McCoy (right) and Delilah Wells Grier are the namesakes and founders of Sistersville. Respectively Charles Wells's 17th and 18th children, they inherited the land on which Sistersville was established from the many acres their father owned along the Ohio River's Long Reach, where he first settled around 1802. (Vincent.)

ON THE COVER: This crew of roughnecks has posed along with a dog and a few tools of the oil trade, framed in by the supports of a wooden derrick. The vast quantities of wood required for building derricks, pump houses, and even the huge planks and trunks used to build a solid base can be seen clearly here. In the background, a four-rail fence surrounds the derrick and what was likely a cow pasture before prospectors drilled yet another well. The Sistersville Oil Field produced thousands of barrels of oil each day during the peak of production. (McCoy.)

IMAGES
of America

SISTERSVILLE AND TYLER COUNTY

Luke N. Peters

ARCADIA
PUBLISHING

Published by Arcadia Publishing
Charleston SC, Chicago IL, Portsmouth NH, San Francisco CA

Printed in the United States of America

Library of Congress Catalog Card Number: 2007924316

For all general information contact Arcadia Publishing at:
Telephone 843-853-2070
Fax 843-853-0044
E-mail sales@arcadiapublishing.com
For customer service and orders:
Toll-Free 1-888-313-2665

Visit us on the Internet at www.arcadiapublishing.com

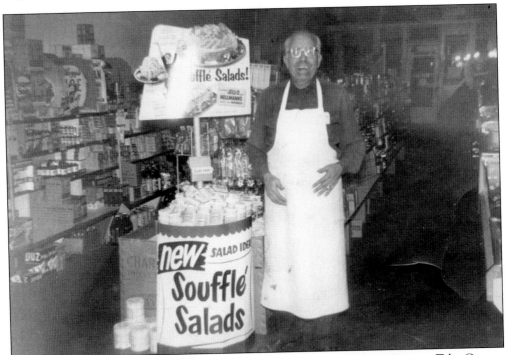

DEDICATION. This book is dedicated to my grandfather, George Shaheen Peters, a Tyler County Merchant for nearly 60 years. He was born in 1893, the same year Sistersville was reborn as an oil town. Coming to West Virginia from Lebanon in 1921, he peddled wares on his back over the hills of Tyler and Wetzel Counties and then operated stores on Indian Creek from 1931 to 1945, where he met my grandmother Alta Webber. They ran Peters IGA on Wells Street from 1945 to 1963, and he continued to butcher and farm into his 90s. His early life inspired me to write my first published work, *The Peddler*, in third grade, and his creed that work is a reward from God gives me strength to take on challenges and know that anything worth having is worth working for. (Author.)

CONTENTS

ACKNOWLEDGMENTS

There are several people who paved the way for this book through their research, writing, and enthusiasm for history. I would like to acknowledge the following individuals and organizations for photographic credits, providing time and information, or otherwise contributing to my completion of *Sistersville and Tyler County*: to the memory of Walter W. McCoy and family for his photography collection and invaluable accounts of Sistersville's early days, without which this book would not be possible; to the memory of Roy Thistle and family for their donation of photographs to the Sistersville Library; to the Tyler County Museum, particularly Ruth Moore for her boundless energy, assistance, and dedication to preserving all of Tyler County's history; to the Sistersville Library staff; to Barbara and Carrol Vincent for their longtime dedication and work with the Oil and Gas Festival and their lending of many Oil and Gas Festival programs and photographs for use in this book; to Laura Bryant and the West Virginia Antiquities Commission for her cataloguing and research work on Sistersville; to Randy Myers, Frances Mason, Amy Harries, and Ryan Morgan; to Dan and Linda Marrin; to Walker Boyd and the late Jody Boyd for their dedication to Sistersville and her caring and generosity as my art teacher; to the Adam Kelly family; to my father for helping with so much research and for taxing his memory; to my mother for her love, encouragement, and home cooking as well as "promotional efforts" regarding this book; to my wife, Heather, for her support, encouragement, and gentle prodding when I needed it as well as for her help in editing and her adoption of Sistersville as a second hometown; to my brother, sisters, and nephew; to my in-laws Patricia and Michael Sowards, who first sparked my interest in an Arcadia publication with the gift of a book on their town of Princeton; to Kendra Allen, my editor, who guided me from afar and did not interfere too much in my procrastination. Finally, thanks to the city of Sistersville for all that you have been and all that you can be.

INTRODUCTION

The city of Sistersville, West Virginia, located about midway along the length of the Ohio River called the Long Reach, enjoys one of the most beautiful natural settings in the Ohio River Valley. All of Tyler County, in fact, even as it was originally organized as a portion of Ohio County, Virginia, has been noted for lush rolling hills, fertile valleys, forests rich with game, peaceful meandering creeks and streams, and a great concentration of sandy shaded islands along the Ohio River. In 1755, George Washington, then a young surveyor, remarked in his journal that he had camped about midway on the western bank of the Long Reach across from present-day Sistersville. The members of the Lewis and Clark expedition passed through on September 11, 1803, with Meriwether Lewis noting a great many squirrels seen swimming the river, well fed from impressive hickory and walnut trees lining the banks. Later on, ornithologist Alexander Wilson wrote of snowy owls along the river, and James Audubon took in the wealth of nature here.

The natural beauty of Tyler County, fully intact if not enhanced by the changing world around it, remains a joy to residents and visitors alike. However, Sistersville and Tyler County's high point in the trajectory of history was determined by something dark and crude far below the rolling hills. The retreat of prehistoric life, the glacial pressures, and the sands of time determined the pinnacle of worldly importance for Tyler County. When the Sistersville oil field, invisible to the world for so many years, was coaxed to the surface in 1891, Sistersville became the oil capital of the world. The story told through the photographs shared here give a sense of the huge changes experienced by a tiny river town injected with thousands of souls bent on building their fortune from the "black gold" that would spew from Tyler County's thousands of oil wells.

The Ohio River is forever entwined with the history of Sistersville, and it brought the first settler of prominence to the area in 1802. Charles Wells, his second wife, Elizabeth Prather, and many of his 22 children landed their flatboat on a sandy bottom south of Sistersville where he had previously surveyed 200 acres. He was a native of Maryland, where he was born April 6, 1745, and in 1764 married his first wife, the wealthy Michal Owings, who died in 1783 after giving birth to their 10th child. When in his 40s, he immigrated to Bethany, Brooke County, and in 1793, he was a member of the Legislature of Virginia. The Wellses were prolific in general and had already founded Wellsville and Wellsburg to the north. He brought with him the machinery for a horse mill to run for the family and as a business, building it along with the first Wells residence about a mile below where the town now stands. Other early settlers followed, including R. Grier, who opened the first local store in the Wells home; William and Joshua Russell, whose descendant would drill the Pole Cat Well, and James Jolly, who started a ferry across the Ohio.

Charles Wells had 400 acres of land north and south of Wells Landing, as the river town was known, and cleared and cultivated much of it as a farm until he died on his birthday in 1815. His will was the first recorded in Tyler County, created by an act of the Virginia General Assembly on December 16, 1814, from parts of Ohio County. The county was named in honor of John Tyler (1747–1813) from James City, Virginia, who had been a lawyer, judge of the admiralty in 1776, and a member and speaker of the Virginia General Assembly (1778–1788) and who was appointed by

Pres. James Madison judge of the U.S. District Court for Virginia in 1811. His son, John Tyler, was the 10th president of the United States.

In his will, Charles Wells specified the following:

> To my daughter Sarah Wells I give and bequeath a part of the tract of land I purchased from James Caldwell; beginning at the mouth of Whittens Run and running with the wagon road now leading to the Jug Handle Mill to the upper end of the Tanyard Lot, thence up the Run to the back line, thence with said line so far that a due west line come to the corner of the fence as it now stands that divides Simon Seamons and Lemual Scott lots; thence with the meanders of said fence to the River bank; thence with said river bank to the place of beginning be the same more or less; to her and her assigns forever. Also one half of a Tract of Land I located the 9th of May last in Ohio County Land Office, adjoining lands of the heirs-of John Williamson deceased; containing Four Hundred Acres; to her and her heirs or assigns forever.—and—To my daughter Delilah Wells I give and bequeath all the residue or upper part of the aforesaid tract of Land purchased from James Caldwell whereon Samuel Scott now lives: also the one half of the aforesaid Tract I located the 9th of May last; to be divided by a straight line from the River bank between her and her sister Sarah, and her to have the lower part adjoining her other land. The two Tracts to be hers and her heirs or assigns forever.

The line that divided the sisters' possessions is now Diamond Street. In 1815, the two laid out the town and, though it had been referred to as Ziggleton, called it Sistersville because of their joint proprietorship. The plat of the original town contained 96 lots on four streets running back from the river and four running parallel with it. These were named in this order from the river back: Water, Main, Wells, and Brown Betty Streets. The cross streets beginning at the lower end of the town were Catherine, Charles, Diamond, and Elizabeth Streets. Hill and Virginia Streets were subsequently added to the north end of town. The Wells sisters intended for Sistersville to be the county seat, so at the crossing of Main and Diamond Streets, a diamond-shaped spot was laid out around which were to cluster the courthouse, jail, whipping post, and offices of the lawyers. The first court for the county was held at the house of Charles Wells on July 9, 1815, and the first sale of lots was in November 1815. Contracts were at least partially negotiated for the building of a jail and courthouse, but before 1816 had passed, Middlebourne became county seat by legislative order. At first, growth of the town was confined to Water Street. Only small clumps of houses existed, with the majority of property cultivated as farms by families like the Calvins, Talbots, Russells, Stockings, Williamsons, and Thistles. Churches were an important part of the community with Baptist (1835), Presbyterian (1842), and Methodist (1851) congregations established but not all having built churches. In 1884, the railroad was built, right where it remains today, allowing improved access to travel, but riverboats had continuously stopped to do trade with farmers who would bring wool, fabric, cattle, sheep, and a variety of goods to the wharf for sale.

In 1865, Philo and George Stocking attempted to drill a well on Owl Hollow, making it only 525 feet when the drill stuck. Philo Stocking did not give up on his oil hunch, retaining mineral rights that brought him the ire of the town but provided his family great wealth in later years. In 1888, some land leasing occurred for oil speculation, but no drilling took place until around 1890, when Joshua Russell decided to drill an oil well on his farm just above Pole Cat Hollow, two miles north of Sistersville. A polecat is an old nickname for a skunk. The drilling was done by spring pole with tools made in a local blacksmith shop, but they were lost in the hole and the well was abandoned. Russell then contracted with Robert McCormick and John C. McCoy, who took up a large land lease under the name Ludwig and Wheeter and drilled the first oil well in the Sistersville Field, the Joshua Russell No. 1.

The oil and gas boom meant the end of Sistersville as a peaceful, placid, rural community. In the days that followed the first discovery of oil, every train and steamboat coming into Sistersville was loaded with people hoping to strike it rich. The town was ill prepared for the sudden onslaught

of people. The most pressing need was a roof over their heads. This problem was solved by immediate construction of rooming and boardinghouses, erecting tents, running houseboats to the now bustling city, the construction of hotels, and a tremendous boom in individual housing. Houseboats four and five deep stretched for a half-mile in either direction along the Ohio River shore. Within a few years after oil was discovered, Sistersville had erupted into a city of over 15,000 people. Fortunately the town always had good government, which solved many problems created by this influx of people. The waterworks was purchased from Ed Roome and enlarged. An adequate sewer system was installed. The program of paving streets that had begun in 1890 with the purchase of bricks was continued until all the streets and alleys were paved. The streets, by then, had become nothing more than huge mud holes because of the unusually heavy traffic that they bore. Money for these improvements came from deposits made each week by the saloon keepers and gambling house proprietors, since they were operating illegally without licenses.

Sistersville is now closer to what it was before the onslaught of population that made it a rip-roaring oil boom city. The oil flowed for much longer than many expected based on production to the north. As opposed to ghost towns lost in old oil fields of Western Pennsylvania and the Hughes and Little Kanawha River Valleys, Sistersville prospered in a fashion that has carried the benefits of oil to the present day. Though some are lost, the homes, churches, brick streets, and fine public buildings that benefit the town today are a lasting legacy of the incredible story of oil in Tyler County. The bubbling "Devil's Grease" that announced its presence over 100 years ago in Sistersville no longer hides far below the beautiful hills but shows grandly in the living history it left behind.

One

FROM DEVIL'S GREASE TO BLACK GOLD

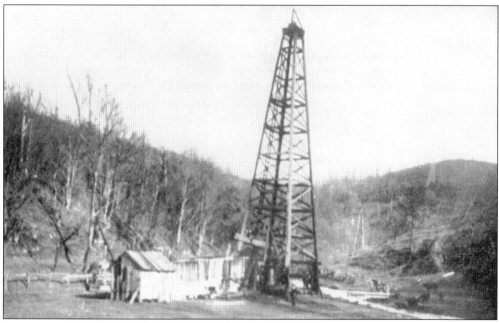

STRIKING BLACK GOLD. The Joshua Russell No. 1 is also known as Pole Cat No. 1 because of its location beside a small stream called Pole Cat Run, which flowed through the Russell farm. About 1889, Russell and Edward Paden drilled there, pumping off saltwater for more than a year before striking oil in 1891. They capped off the well to hide the discovery while they rushed around buying up rights to additional land. As they drilled a second well, a fountain of oil broke loose from the first one and splashed down the creek, causing much excitement among the residents. The news of an oil well producing around 400 barrels a day brought a flood of wildcatters, operators, and merchants to seek wealth from the Sistersville pool, one of the nation's richest and the only one in which water lay on top of the oil. In addition to being the first well of note, Joshua Russell No. 1 was also one of the most productive, reported by Sampson Thistle to still be producing some oil and gasoline in 1925. (Thistle.)

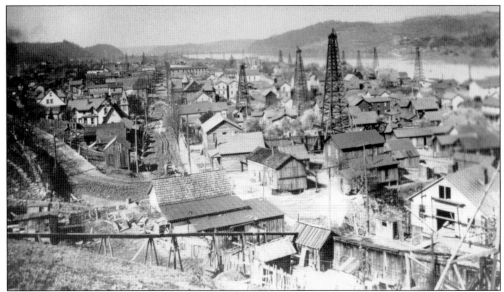

AS COMMON AS TREES. Oil derricks dominate the skyline of 1894 Sistersville, jumbled with houses and oil buildings wherever they fit. Wells Street is muddy with wheel ruts, having only been paved to Hill Street. In this view looking south past Cemetery Hill Road, St. Paul's Episcopal Church is at left, the Arlington Hotel with many windows is near the center, and the Wells Hotel is at the distant left. (Thistle.)

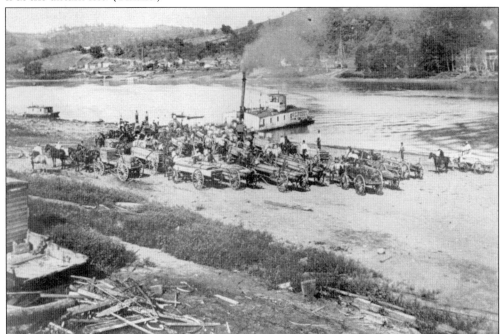

A RIVER RUNS THROUGH IT. Even after the arrival of rail, the Ohio River remained critical to freight transportation for the oil industry and many of the merchants of Sistersville. Here a fleet of W. H. Noll's wagons, built on Main Street, is being loaded with pipe, heavy rope, and common goods from the steamer *W. C. Pusey*, moored on the sandy bank at summer low water stage. (Vincent.)

DANGEROUS WORK. Hugh Cronin fills a torpedo used in "shooting" wells, a procedure used to remove clogging sand and waxes. Up to 120 quarts of nitroglycerin were poured into torpedoes and lowered into the shaft with a detonator attached. Early detonations involved dropping something down the shaft, which sometimes meant injuries or death if rocks were blown loose. (Author.)

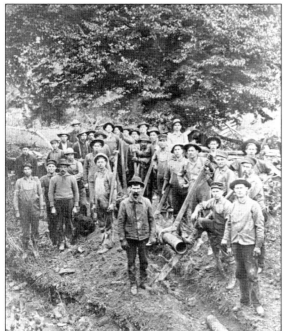

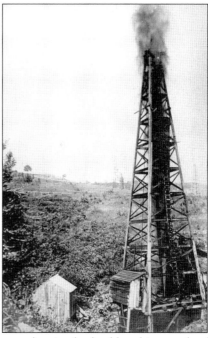

MAKING GIB PROUD. Oil field crewmen used huge wrenches in the backbreaking work of connecting steam lines or pipeline like that seen crossing the hills behind this gusher. Work in the oil fields was dangerous and exhausting, but a drink from a saloon and a trip to a "chiropractor" in one of Happy Hollow's houses of ill repute would ease the pain. Levity and camaraderie, as provided by Gib Morgan, the "minstrel of the oil fields," was also celebrated. He worked the Sistersville field, spinning tales and lies that made his legacy larger than life. Several events at the Annual Oil and Gas Festival are named in his honor, including the wrench throw. (McCoy.)

13

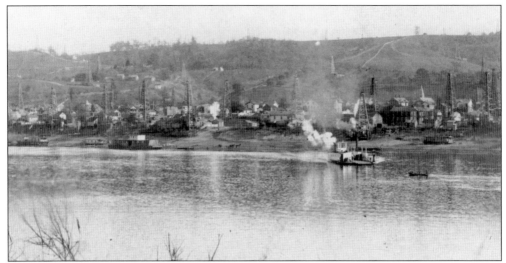

BANKS OF A BOOMTOWN, 1893. The ferryboat pulls away from Sistersville's shore, where the wharf boat and houseboats are moored on the broad sandy beach. The 1840 Russell building and adjacent storehouse are visible, and above them are the unmistakable gingerbread of the 1884 home at 816 Main Street and the steeple of the old Presbyterian church. Note the pipeline crossing the bare hills over town. (Thistle.)

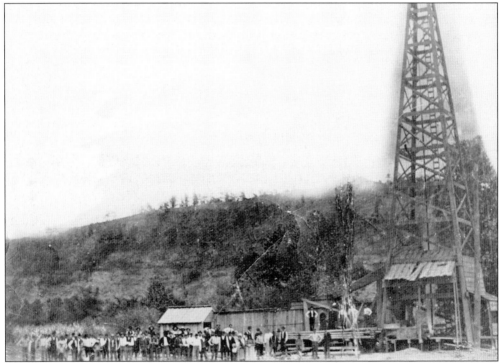

BIG MOSES. Victor Oil and Gas Company struck gas August 3, 1894, on the Indian Creek farm of Moses Spencer. The pressure was so great that it took many attempts to cap, and it would blow barrels 300 feet in the air. The rush of 100 million cubic feet of gas per day could be heard for 10 miles. Experienced operators said it was the greatest gas well ever developed in the United States. (Author.)

14

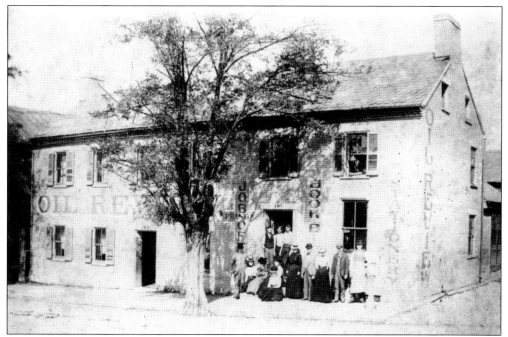

BUILT TO LAST. The Russell Building, built in 1840 as a ferry house, served as a market for cordage, hardwood, oils, tars, and food supplies. On the National Register of Historic Places, it still stands strong despite many floods and uses. In 1895, it housed the *Oil Review*, a weekly paper long edited by J. Hanford McCoy and read anywhere that oil was the business of the day. (McCoy.)

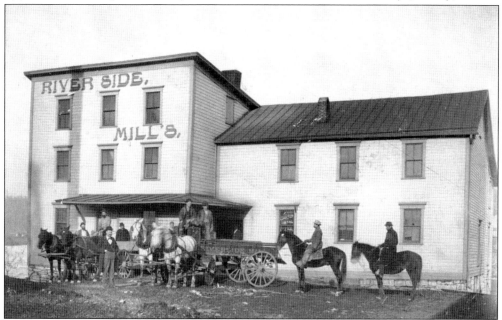

RIVERSIDE MILLS. Later run by E. L. Roome, Riverside Mills was built by Philo Stocking, who moved to Sistersville in 1841. A pioneer oil driller in 1865, he kept detailed diaries and charts. His drilling tools stuck in the well at 525 feet and were abandoned. Since he maintained the oil and gas rights on land he sold, his family was later rewarded by his foresight. (McCoy.)

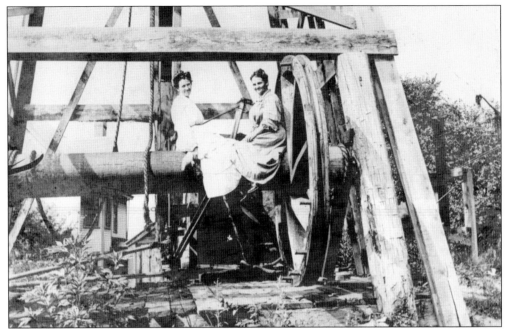

SITTING PRETTY. The citizens of Sistersville grew more comfortable with the towering oil derricks found around every corner after they had made the town rich and famous. Shown here are Alice McCoy (left) and Ella Collier in 1904 having a seat on the bull wheel of a wooden derrick used to coil drilling line. (Tyler County Museum.)

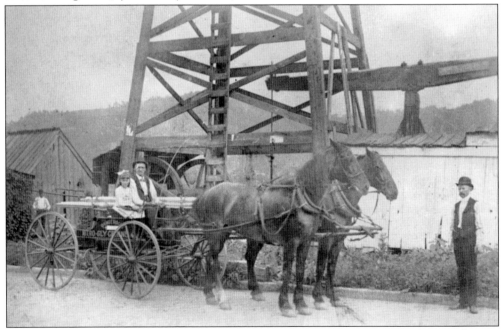

PRECIOUS CARGO. An Agnew Torpedo Company shooter wagon in front of Stocking Well No. 1 is loaded with long tin torpedoes made by Fred Abram's tin shop on Alley B. Shooters George Blythe (right) and "Daddy" Graham pose with little Alice Skaggs, who seems unfazed by the deadly load of nitroglycerin under her seat. Such was the life of a young oil-town girl. (Thistle.)

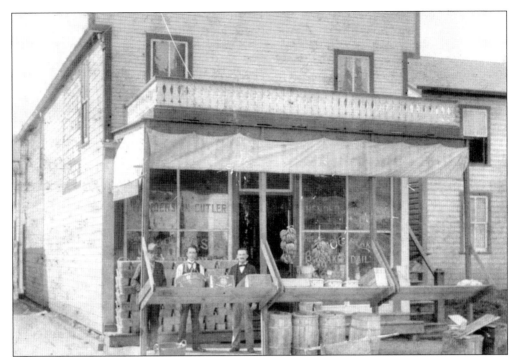

YES, WE HAVE BANANAS. The Henderson and Cutler Grocery Store, at the corner of Elizabeth Street and Alley B, placed fruits, vegetables, soaps, and other goods along the sidewalks, hoping to lure Sistersville shoppers. The town's stores were stocked with items such as bananas, an exotic fruit that was normally only available in larger cities. The sign in the window reads, "Bread, Pies, and Cakes Baked Daily." (McCoy.)

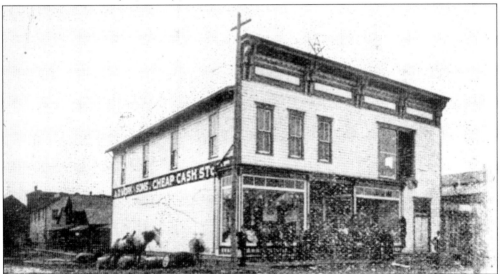

ONE-STOP SHOP. In 1893, one could get about anything "for cheap and for cash" at the A. D. Work and Sons General Store. Built by J. S. Pierpoint and C. C. McCormick in 1886 at the corner of Chelsea and Diamond Streets, the building housed Hinerman Brothers Department Store years later. As seen by the square and compass on the top of the building, the first Masonic Lodge Hall was on the second floor of this building from 1887 to 1898. (Thistle.)

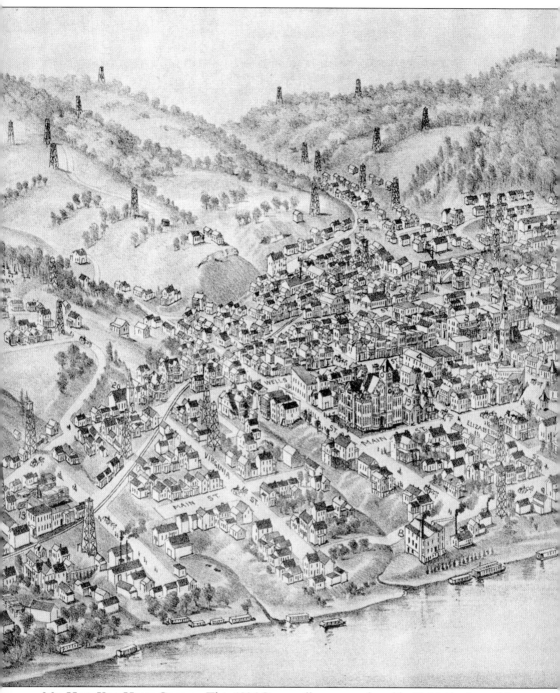

MY, HOW YOU HAVE GROWN. This 1896 Sistersville map produced by T. M. Fowler and James B. Moyer of Morristown, Pennsylvania, was sold only by Frank Phillips. The quality drawing shows a fine amount of detail representative of daily activities of the time. The key reads: 1. High School; 2. Hotel Wells; 3. Hotel Olsten; 4. New Arlington Hotel; 5. Riverview Hotel; 6. O.V.R.R. Station; 7. Carter Oil Company; 8. Riverside Mills; 9. Jumbo Manufacturing; 10. Leibecker Tool

18

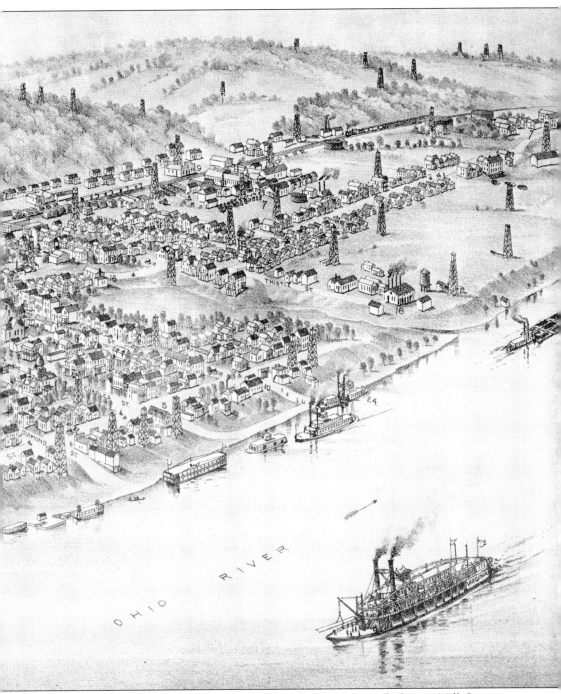

Company; 12. Sistersville Oil and Gas Well Tube Works; 13. Russell Planing Mill Company; 14. Gold and Jones Tank Manufacturers; 15. Stoner Machine Shop; 16. Eureka Laundry; 17. Sistersville Laundry; 18. Thistle Station Eureka Pipeline; 19. Catholic Church; 20. Episcopal Church; 21. Methodist Church; 22. Baptist Church; 23. Presbyterian Church; 24. Sistersville Steam Ferry Boat *Orion*. (Vincent.)

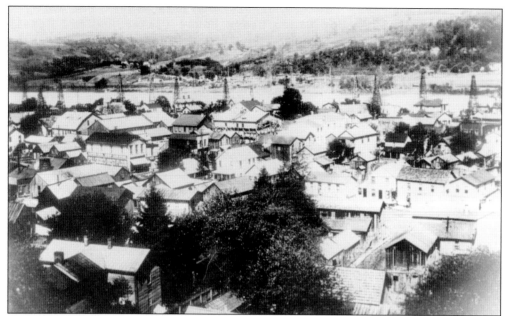

BOOMTOWN SISTERSVILLE 1892. An early picture of Sistersville taken from McCoy Heights shows the Olston Opera House (later Hosford Hotel, Mercer Hotel, and the Tavern) under construction and A. D. Work's store, built in 1886 with the Masonic Lodge upstairs and a Pillsbury sign on the side. The tower of the First Presbyterian Church is seen at left over the river, and the Jones Hose House is at far right on the diamond. (Thistle.)

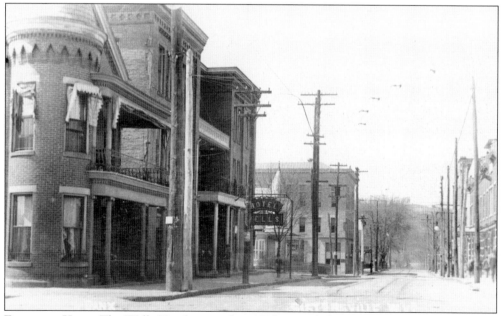

FIT FOR A KING. The Wells Hotel, opened in 1895, provided respite for Sistersville's genteel guests when accommodations were hard to find. W. B. O'Neill was architect and John J. Rea was contractor for the hotel and residence for Ephraim Wells at the left of the photograph. In 1965, J. Wells Kinkaid, grandson of Ephraim Wells, remodeled the hotel from top to bottom and opened it under the name Wells Inn. (McCoy.)

Two

WEALTH ON WELLS STREET

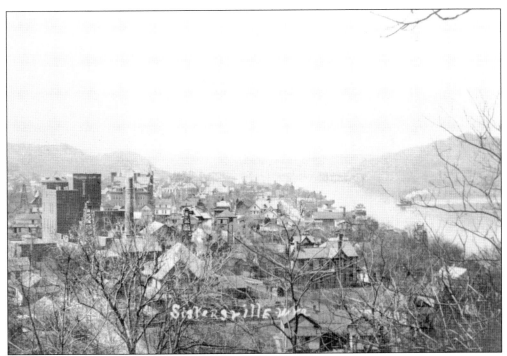

CITY OF INDUSTRY. This 1908 view of Sistersville from north of town is dominated by the Sistersville Brewery, or the Ohio Valley Brewing Company, as the operation was known from 1908 until it closed in 1911. The towering Main Street School is south of the brewery smokestack, and oil derricks have been largely replaced by stately homes and a much grander and bustling commercial district. The river remains an integral part of the trade and industry, with the wharf boat and stern-wheeler ferryboat *Daniel* shown to the right, but the railroad has increased in use, allowing the Carter Oil Yard and most other manufacturing to move to the base of the hill along the Baltimore and Ohio (B&O) Railroad in Gary Owen. (Thistle.)

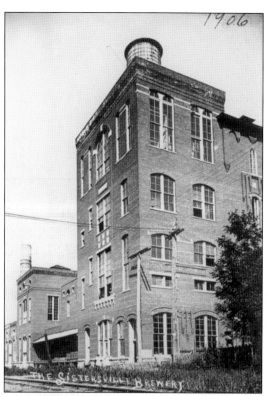

BOTTOMS UP AND BOTTOMED OUT. Sistersville Brewery, between Wells and Carter Streets, was impressive, but the beer was not, and the original mortgage was foreclosed on in 1908. It reopened as Ohio Valley Brewing for three years until a lawsuit with Detroit Steel over the brewing tanks and poor business caused all but the icehouse to cease operations. The American Brewing Company operated elsewhere in town until 1938. (Thistle.)

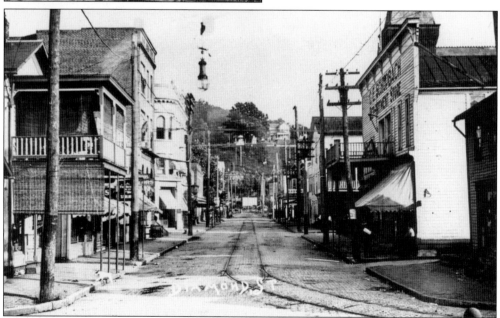

RIGHT ON TRACK. This view looking east on Diamond Street with trolley tracks running down the middle shows the Shupbach Department Store, the steeple of the old Baptist church, and the Tavern on the right, which are all gone now. The building on the left with the porch, the Farmers and Merchants Bank, and the former Peoples National Bank across Wells Street still stand. (McCoy.)

**WILD, WILD WEST
VIRGINIA.** The image at
right of Sistersville in August
1894 resembles frontier
Sistersville with dirt streets
and a mix of houses and
small buildings lining Wells
Street. Major investments
were made at the intersection
of Wells and Charles Streets,
with the First National Bank
set to open at left and the
Hennaghan-Daly Building
under construction. The
palatial Richardsonian-style
building took up nearly half
a city block with a club room,
saloon, and shops on the
first floor and a gambling
casino on the second floor.
In 1899, the Phoenix Club
was downstairs, and the
Show occupied the section
facing Charles Street, which
became the Paramount
Theater in later years. (Right,
McCoy; below, Thistle.)

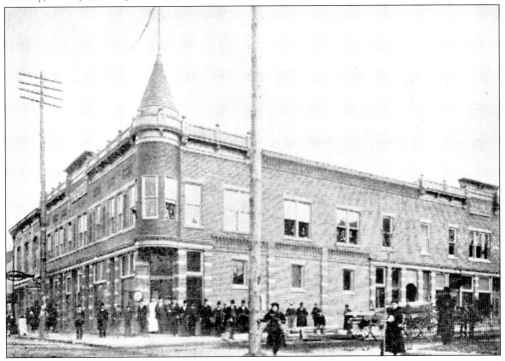

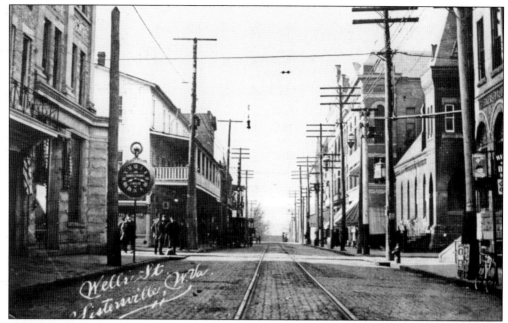

THE HEART OF IT ALL. Wells Street, heart of the Sistersville business district, was home to banks, saloons, hotels, and various stores that served the population in town and the surrounding county. The saloon is at left, and the old Baptist church, at right, would eventually give in to the high value of the commercial property where it stood. Note the Sherwin-Williams paint sign at right. (McCoy.)

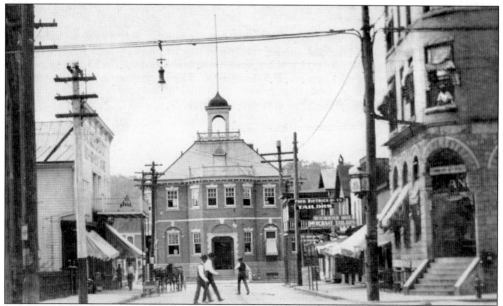

AMERICAN COLONIAL. A photographer capturing this view looking west across Wells Street at the 1897 City Building caught the attention of a woman looking from the window of the Bell Telephone Exchange Office on the second floor of the Farmers and Producers Bank. On the right side of Diamond Street are also Reicherter Brothers Tailors, Fred Dietrich and Company Tailors, and C. B. Disque's first drugstore at the far corner. (Thistle.)

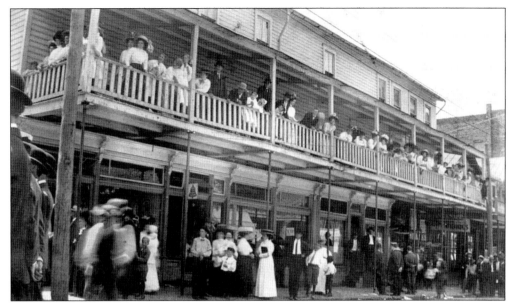

A Patriotic Perch. Folks are packing the balcony of the Saloon on July 4 around 1900 to get a view of the annual Independence Day parade. The building housed several businesses, including Knapp and McMullin at 707 Wells Street. It was built in 1892 as the Olston Opera House and later became the Hosford Hotel and then the Mercer Hotel. (McCoy.)

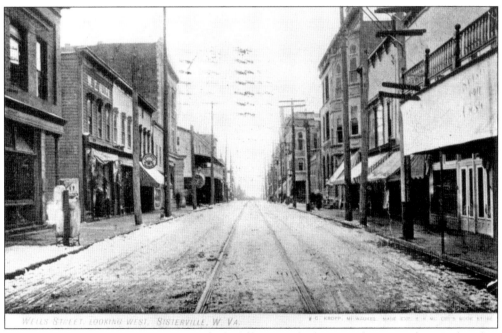

A Cold Winter's Day. This postcard of Wells Street looking south was made in Milwaukee by C. Crop expressly for E. R. McCoy's Bookstore. The sign at 614 Wells Street on the right is for Dr. V. N. Jones, who the 1902 *Daily Oil Review* said was a leading dentist in Sistersville. The W. E. Allen sign is on 619 North Wells Street, which has been the location of Dudley's Florist for many years. (McCoy.)

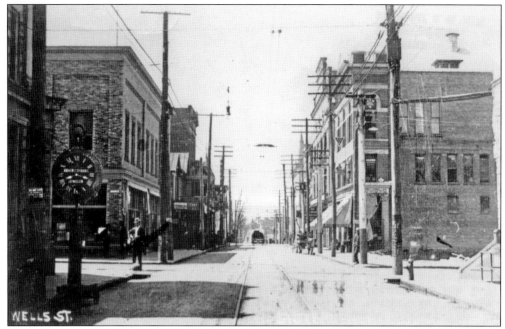

HANDS OF TIME. Change was inevitable on Wells Street when the saloon was lost in a fire and the Baptist church demolished. The saloon was replaced with the brick building on the left, new home of the C. E. Shupbach store. It later housed G. C. Murphy following the December 1970 fire that wiped out half the block. The clock near the corner of Diamond Street advertises Abner C. Thomas, Jeweler. (McCoy.)

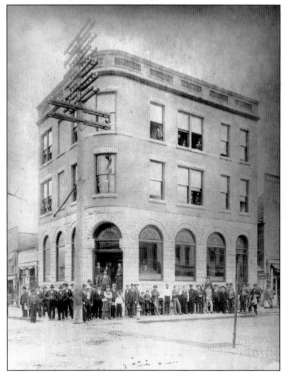

FARMERS AND PRODUCERS BANK. The bank opened January 1, 1896, in this building at the corner of Diamond and Wells Streets. The raised main floor features arched, colorful stained-glass windows that are still intact. At the time of this photograph, the Kanawha Oil Company was located on the second floor. (Thistle.)

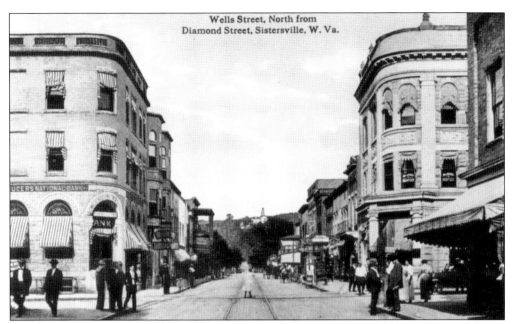

FINANCIAL FOUNDATIONS. This postcard of Wells Street looking north from Diamond Street shows the Farmers and Producers Bank at left and the building built as Peoples National Bank at right, which features unique decorative stonework and was the location of a second-floor dentist's office for years. The two banks later merged to form the Union Bank, which occupied the ornate Peoples building until about 1977. (Tyler County Museum.)

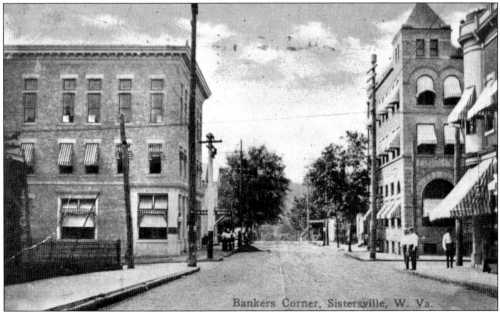

BANKERS CORNER. The west side of the Wells and Charles intersection is still home to two banks. The Thistle Building, built in 1905, houses First Tyler Bank and Trust Company, originally the Tyler County Bank. Opening in 1892, it was the first bank in Tyler County. Incorporators were E. A. Durham, A. C. Jackson, J. T. Jones, Ephraim Wells, and Robert McCormick. The first officers were Durham and Jackson. (McCoy.)

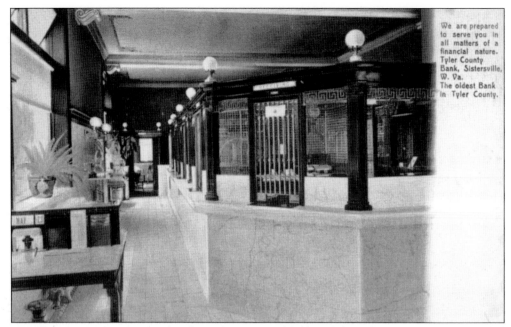

We are prepared to serve you in all matters of a financial nature. Tyler County Bank, Sistersville, W. Va. The oldest Bank in Tyler County.

MARBLE AND MAHOGANY. The elegantly appointed lobby of the Tyler County Bank handled millions of dollars in deposits from Sistersville residents. The first National Bank and Tyler County Bank merged in 1921, and the name changed to Tyler County Bank and Trust. The bank purchased the building from the Thistle heirs in 1955. (McCoy.)

FIRST NATIONAL BANK AND NATIONAL ACTS. In 1900, this stately section of Wells Street featured the First National Bank, the chevron-bricked Morrison Building, and the opera house, also known as the auditorium. Initial 1895 bank stockholders were J. T. Jones, A. C. Jackson, S. G. Pyle, Robert McCormick, E. A. Durham, O. W. Hardman, J. C. Morrison, Frank McCoy, G. W. Stocking, H. W. McCoy, E. B. Hutchison, D. C. Garman, C. P. Russell, L. A. Brenneman, and Charley Thistle. (McCoy.)

FEZZES AND FURNITURE. The Masonic Lodge, built 1898, housed Ike Simon's One Price clothing and furniture store at street level, with Olston Opera House to the right and the Brilliant Saloon at left. The lodge and opera house were razed to make room for the new and larger temple built in the 1920s, where three Masonic emblems from the old facade were saved and placed in the wall behind the master's chair. (McCoy.)

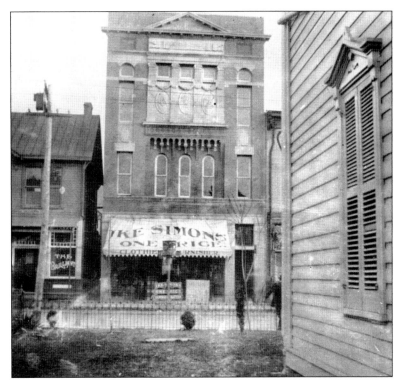

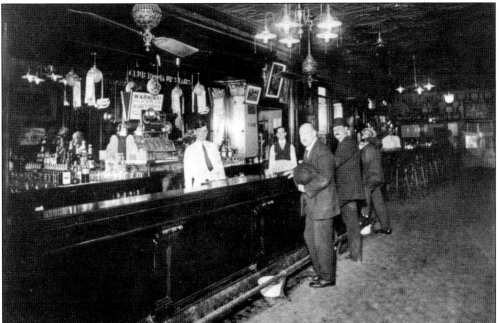

WHERE EVERYBODY KNOWS YOUR NAME. The Brilliant Saloon and Wholesale Liquor Store, owned by R. M. and M. L. Clendenning, opened August 8, 1899, with Springer's Restaurant at the end of the barroom. A 1902 *Daily Oil Review* advertisement read, "To keep within the bounds of safety, make your purchases of wines and liquors, as beverages or for family or medicinal purposes from the house which has proven worthy of trust." (McCoy.)

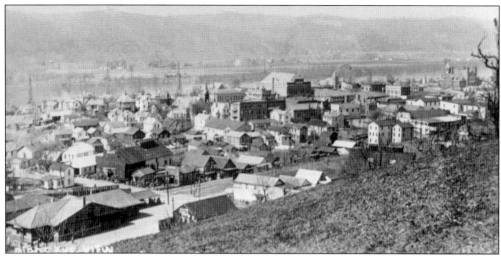

ON A CLEAR DAY. Looking northwest over the B&O Depot, the size of the opera house is very evident at center, and the high bell tower that graced Main Street School is seen at right. The Wells Inn, Methodist Episcopal church, and Nazarene church are familiar today, but at the time, homes and businesses covered City Park and oil derricks still lined the river. (McCoy.)

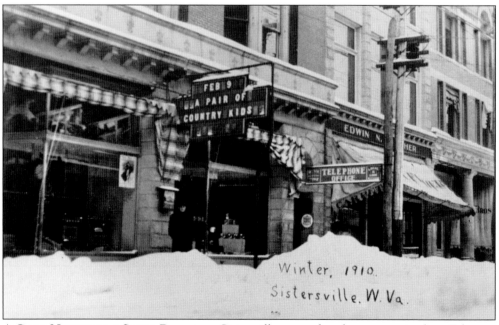

A GOOD NIGHT FOR A SHOW. Downtown Sistersville was under a heavy snow in about February 1910. The marquee of the opera house announces the upcoming featured play *A Pair of Country Kids* to be presented on February 9. The building also housed the West Virginia Western Telephone Office and retail establishments like the Edwin N. Fischer carpet store on the right. (Tyler County Museum.)

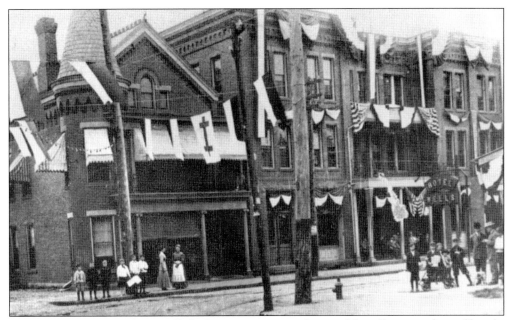

YORK RITE WELCOME. Sistersville had a reputation as a clean and friendly city with good hotels, which brought several state conventions and meetings to town. Bunting, flags, and banners draped the Wells Inn and downtown streets, giving a festive look for the 36th Annual Conclave of the Grand Knights Templar of West Virginia, held in May 1910. (Vincent.)

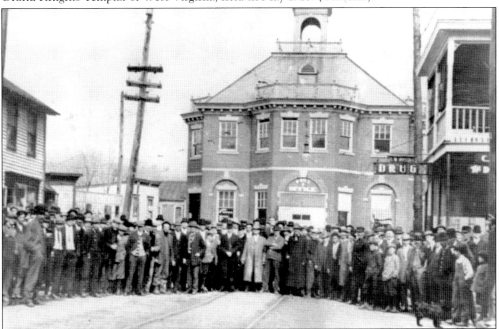

DIAMOND RIOT. These citizens assembled in front of the City Building to demand that the Methodist reverend ? Shultz be released from the basement jail. He had been arrested for protesting against illegal voting during the 1912 city elections. Shultz was released after the "riot," and several city officials left town, returning after tempers had cooled. Notice that the post office was located in the City Building then. (Thistle.)

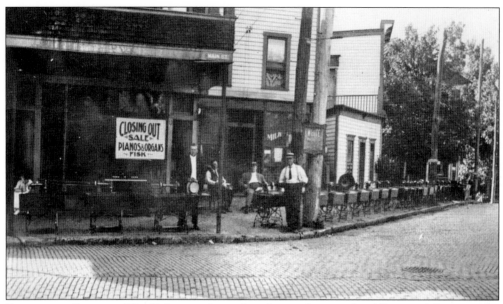

SONGS AND SINGERS. The Fisk store, located at the southwest side of Diamond Street at the Main Street corner, was having a "closing out sale" of pianos, organs, and Victrola record players this day. There are also several sewing machines lining the sidewalk. Most folks in Sistersville could afford to have these fine items in their homes. (McCoy.)

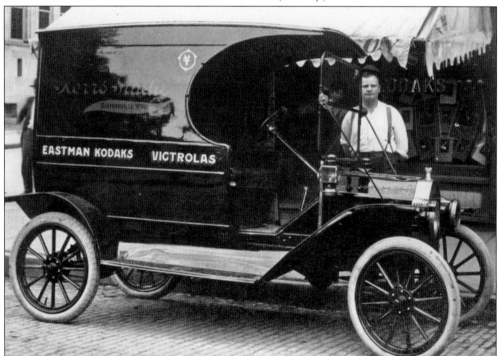

PICTURE PERFECT. Art Kerr and his shiny truck are seen here in front of his studio at the corner of Elizabeth and Wells Streets. Kerr's produced fine portraits of many individuals, including Henry Woodson McCoy, as seen on page 86. Kerr's also dealt in Victrolas with a focus on Eastman Kodak photography. The existing post office is seen in the background. (McCoy.)

UP ON MAIN STREET. Shade trees, cast-iron fences, and hitching posts line Main Street, and buggies can be seen waiting outside the W. H. Noll and Son's Carriage Shop in the summer of 1910. The three-story 1903 Noll building, across the street from the Methodist Episcopal church, was the first concrete-block building in the area. The first floor was an office and harness shop, the second floor a paint and upholstering shop for carriages and buggies, and the third floor a paint shop for wagons and carriages. The painter, Charlie Kernberger, was a true artist; even the gypsies brought their wagons and carriages to Noll and Son's for painting. Notice the cupola on the city building, which was later removed. The Henderson home at 605 Main Street, on the corner of Elizabeth Street, was built in 1898. The sturdy-looking 1840s building next door was demolished in the 1970s and hides the view of the Bert Noll house, which still stands next to the carriage shop today. (Tyler County Museum.)

GREETINGS FROM "THE VILLE." This postcard shows Elizabeth Street looking east at McCoy Heights. Notice the Ephraim Wells hose house standing at the end of the street and the gas lamp in the foreground. The large brick house at the right is the Thoenen Home with its carriage house, which still stands behind it today. Kerr's Studio is the building with the awning at the corner of Wells and Elizabeth Streets. (McCoy.)

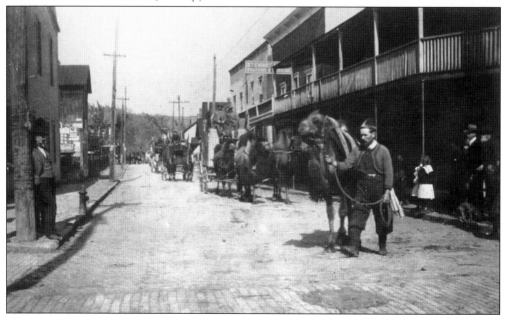

CIRCUS ON PARADE. These camels are parading up Hill Street between Main and Wells Streets on September 30, 1903, as a part of the Forpaugh Circus. The rarely photographed buildings to the right, which sat on the edge of a ravine, included Stewart Boarding and Lodging. The corner to the left is the site of the present Baptist church. (McCoy.)

CROSSROADS OF TIME. Before the crossing was built, this is where the trolley tracks ended at the B&O railroad tracks on Wells Street. Sistersville was one of the first cities in the nation to have all its streets and alleys paved in brick. Labor Day is soon, signified by the banner for the Ancient Order of United Workmen (AOUW) hanging over Wells Street. John Jordan Upchurch, a Mason, founded the organization in Meadville, Pennsylvania, to answer the plight of the new class of industrial workers. It was the beginning of the American fraternal benefit network, providing $500 upon the death of each member who had made a $1 contribution to the fund. Many in Tyler County gained significant wealth during the oil boom, but it wasn't until 1925 that Standard Oil and thus Carter Oil, a subsidiary, switched from a 12- to an 8-hour day, simultaneously raising the pay rate from $1 to $1.25 per hour. Notice the signs advertising a lot sale in Paden City, billed as "The New Industrial Town." (McCoy.)

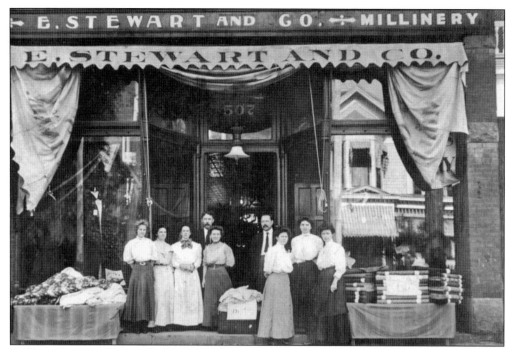

A WELL-DRESSED TOWN. E. Stewart and Company Millinery clerks pose in front of the shop at 507 Wells Street in 1910. Eliza, George, and M. V. Stewart organized the firm in 1892, of which the 1902 *Daily Oil Review* said, "It is not necessary to go to the big city for the latest fancies and originalities, as their stock will always be found up to date and very desirable." (McCoy.)

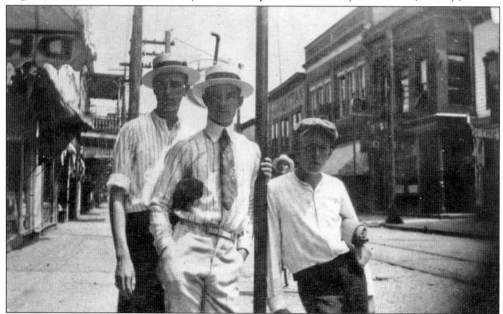

THE BOYS CLUB. These dapper young men on Wells Street are ? Peterson (left), ? Collins (center), and Frank Mitchell. The straw boaters, driving cap, and short tie were smart summer style for picnics, boating, or tennis through the 1920s. The building over Frank's shoulder was the Tyler County Bank from 1895 to 1906, with the Manhattan Saloon one door up. (McCoy.)

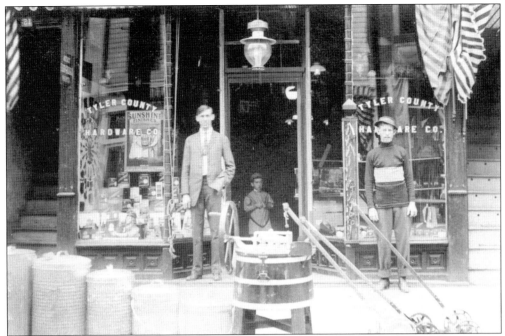

COME ON IN. Tyler County Hardware offered a little bit of everything from its location at 621 Wells Street. Lou Henderson (left), proprietor, and Cecil Haines pose here with an unidentified child and window displays of Dutch Boy Paint, Sunshine Finishes, brushes, assorted shaving razors, scissors, fishing poles, push mowers, and a hand-crank wringer washer on the sidewalk. The interior shows an array of sporting and hardware goods such as Spalding baseball bats, a cooktop gas stove, pots and pans, ASK metal polisher, padlocks, lanterns, and bolts and nails in the boxes along the bottom of the counter. This building still houses a hardware store, with the entrance one door south. (McCoy.)

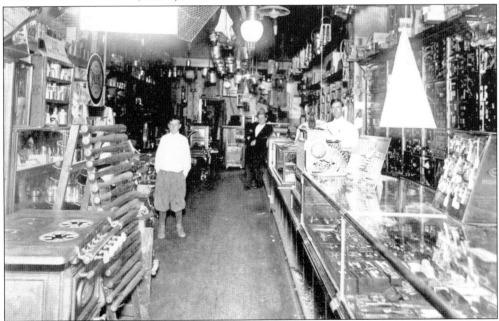

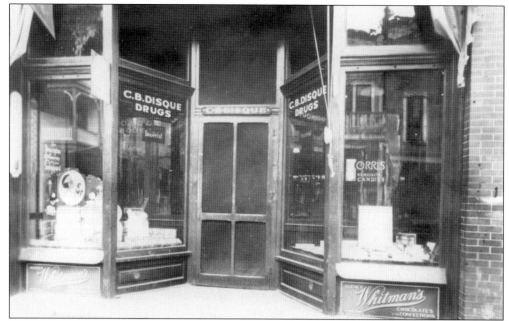

GOOD FOR WHAT AILS YOU. C. B. Disque Drugs was at 615 Wells Street between Elizabeth and Diamond Streets. Disque Drugs was formerly on Diamond Street at the corner of Alley B. Disque bought the operation from ? Hendershot, Cline McGregor bought the C. B. Disque store in 1952, and Jim Phillips, who runs Phillips Pharmacy at this location, bought the store from McGregor in 1964. (McCoy.)

MAGAZINES, CIGARS, AND MORE. The Knapp and McMullin Store at 707 Wells Street, located in the saloon, was founded about 1902. The *Daily Oil Review* said they carried stationery, news, confections, cigars, tobacco, magazines, sheet music, and "many small novelties . . . such as are not found in any other stores in the city." Tyler County once had several newspapers, all of which would have been available here. (McCoy.)

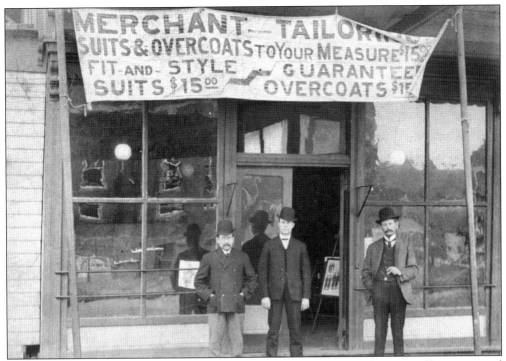

$15 SUITS. Reicherter Brothers Merchant Tailoring once advertised fitted suits as well as guaranteed overcoats for only $15. The store was on Diamond Street in the 1890s. Notice the print advertisement showing different styles of coats propped in the doorway to attract the attention of customers. The establishment lasted with the same name and location until the 1960s. (McCoy.)

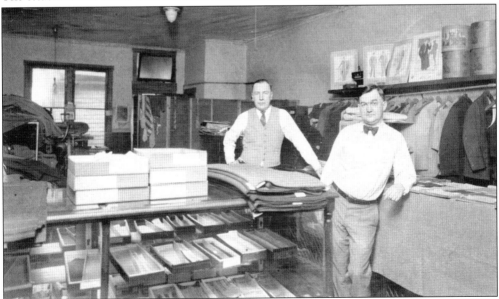

STEAM AND PRESS. Ray Webber (right) and Emmit Hill stand in Hill's Pressing and Cleaning, located in a downtown second floor. They also sold hats, ties, and handkerchiefs, as seen in the display case. Notice the decorative Viking Hat Company boxes on the shelf at right. The style of suits advertised would date this photograph to about the 1920s. (McCoy.)

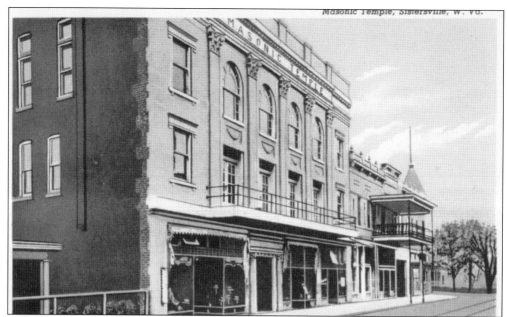

MASONIC TEMPLE. This postcard shows the Sistersville Masonic Temple built by Phoenix Lodge No. 73 A.F. & A.M. on Wells Street, replacing the previous building, which became unsound around 1920. Lodge activity began in Sistersville on February 12, 1878, initially meeting in the Odd Fellows Hall, then the Cox store and the Work store before meeting on Wells Street. The Phoenix Lodge incorporated the membership of the Friendly Masonic Lodge in 1946. (Tyler County Museum.)

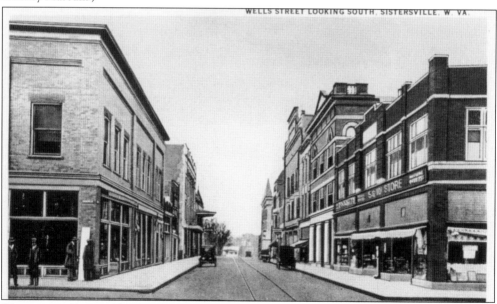

NICKEL AND DIME. After fire destroyed the saloon and the old Baptist church was demolished, the yellow-brick Shupbach Store at left and the Fischer Block faced each other on Wells Street for several years. G. C. Murphy relocated from the Fischer Block after the terrible fire of 1970 and expanded across the street, using space formerly occupied by Springer's Restaurant to open a luncheonette. (Tyler County Museum.)

Three

CHURCHES AND
PUBLIC BUILDINGS

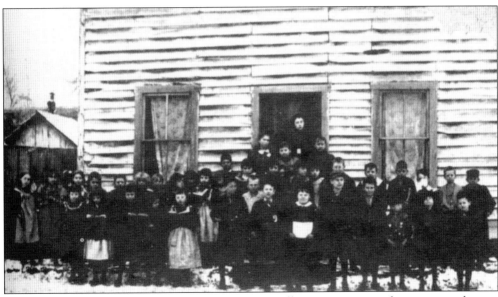

SCHOOL DAYS. The first organized school in Sistersville was a one-room log structure that sat on the diamond where the city building now stands. In 1840, a frame building was completed nearby. From 1882 to 1891, the population grew beyond the small group of students at the Wells Lane School above or the Main Street School. They would gain many classmates as the oil boom raged from 1891 to 1895, when the number of school-age children increased tenfold. The two-story brick school on Main Street was replaced with the magnificent Main Street School, which served as a high school and after 1906 as a primary school. Segregation was the law then, meaning the few black children in town attended classes first in Wells Lane School after the student body had moved to Main Street and later in the five-room south-side building that replaced the Wells Lane School. By 1920, the black population of Sistersville was so small that students had to travel by trolley to Paden City for school. (Sistersville Library.)

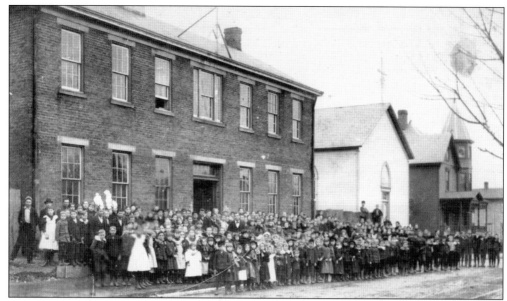

CLASS PICTURE. Main Street School students assemble for a photograph in the winter of 1894. The brick, two-story, four-room schoolhouse was built in 1869 and used until 1896, when a much larger, more modern high school was built on the same lot. Holy Rosary Catholic Church, founded in 1893, is just to the right, where the parish remains today, though the building has added a bell tower and was remodeled after a 1950 fire. (Thistle.)

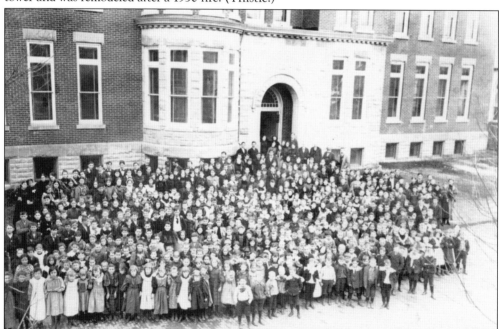

NEW FRIENDS. The Victorian-style Main Street School was unique for the amount of natural light, the third-floor gymnasium, and the bell tower nearly five stories high, which featured prominently in the Sistersville skyline. Over 92 years, thousands attended Main Street School as a high school, middle school, or elementary school until it closed in 1989, including the first Sistersville High School (SHS) graduates, Zelma Minamyer and Bertha Jane Smith. (Thistle.)

THE PALACE OF MAIN STREET. Board of education members G. L. Lowther, A. D. Work, and D. L. Core contracted for the construction of the school at Hill and Main Streets. Completed in February 1897 after about 10 months of construction, Main Street School cost only $45,000 to build. The building had 13 classrooms, 3 recitation rooms, a library, high school assembly room, and an auditorium for 600 people. (McCoy.)

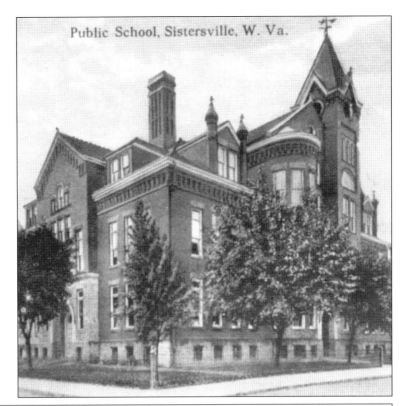

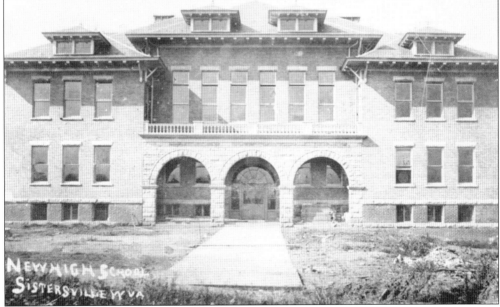

DEAR OLD SHS. Sistersville, unlike the rest of Tyler County, was served by an independent legislatively created school district with elected commissioners. In 1906, voters approved the building of the terra-cotta brick and Cleveland limestone building overlooking the river on Work Street. Sistersville High School, the home of the Tigers, was built with 15 classrooms, a library, assembly hall, and laboratories for around $45,000. (McCoy.)

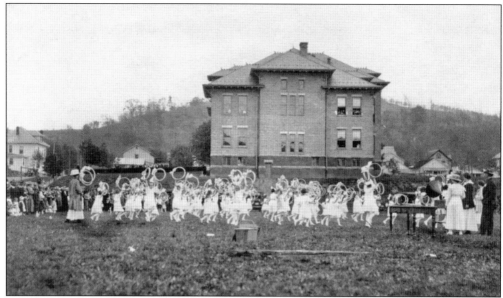

ALL TOGETHER NOW. Young girls are observing the 1909 May Day traditions on the SHS athletic field while their parents and others look on from windows, sidewalks, and the sideline. SHS alumni, historically one of the most active high school alumni groups in the country, have a May tradition of holding class reunions every Memorial Day, including a parade, dances, dinners, and an honored alumnus speaker. (McCoy.)

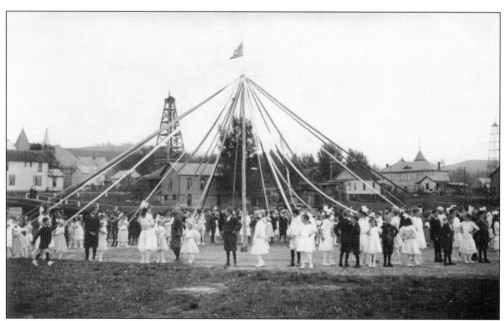

AND THE BOYS JOIN IN. Boys and girls line up for the dance around the maypole, an annual rite of spring. From the SHS athletic field later named Core Field, the Gary Owen School, known as the south-side school building, can be seen in the right background, along with the steeple of the current Christian church at far left and several oil derricks. (McCoy.)

MOLDERS OF MINDS. Teachers of the Gary Owen School at the corner of Clay Street and Wiley Avenue in 1906 were, from left to right, Bessie Varner, Eva Daughton, Cliff Hamilton, and Belle Vannoy. After 1906, when the new Main Street School became a grade school, the building was used by the town's few black students. Eva Daughton later taught at Main Street School into the 1950s. (McCoy.)

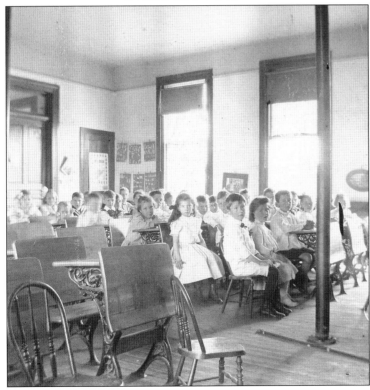

BEST BEHAVIOR. These first-grade students were some of the last to attend the five-room Gary Owen School in 1906. The boys dressed in short pants and the girls all in dresses had moved to one side of the room for the photograph. Sistersville's latest elementary school opened in 1976 on Maple Lane overlooking town. Compared to the cost of building the two high schools, the current elementary school cost nearly $1 million. (McCoy.)

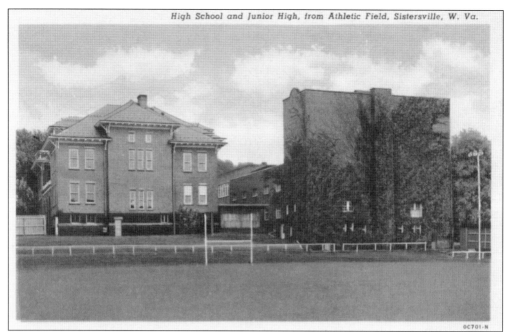

High School and Junior High, from Athletic Field, Sistersville, W. Va.

OC701-N

CORE FIELD. This picture postcard shows a view of Sistersville High School with the new junior high school addition completed in 1925. Eight classrooms were added, along with a gymnasium-auditorium that could seat over 1,000 people in chairback seats and a wraparound balcony. The tall, ivy-covered section is the stage area of the gymnasium; the height allowed a variety of backdrops to be raised and lowered for performances. (Author.)

Razoo! Razoo! Johnie, Blow your Bazoo!
Yip-skip! Yip-skip! Sis – Boom – Bah!
Sistersville High School. Rah! Rah! Rah!

TIGER SPIRIT. These early SHS "cheerleaders" would have really been proud of their Tigers when coach Lou "Louie" Nocida led the kings of the Mountain State to four state championships in six straight title game appearances from 1980 to 1985 and set an all-time state record for consecutive regular-season victories. Tiger teams also brought home the state football title to Sistersville in 1953 and 1964. (McCoy.)

46

CLASS PLAY, 1910. As late as 1919, there were 161 schools in Tyler County. Students not living in Sistersville, Friendly, or Paden City attended Tyler County High School, built in 1908 as the first county high school in West Virginia. The Red Raiders slipped past SHS in the 1983 All–Tyler County state championship game for their only football title. The Lady Raiders won a state basketball championship in 1981. (McCoy.)

TWO-TIME GOVERNOR. Cecil Harland Underwood, born 1922 at Joseph's Mills, graduated from Tyler County High School. He represented Tyler County in the West Virginia House of Delegates at 22. After becoming the youngest-ever West Virginia governor in 1956, he was again elected in 1996, becoming the eldest governor. He and his late wife, Hovah, visited the family farm often during both administrations. (Tyler County Museum.)

47

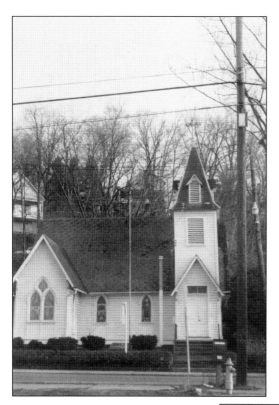

OLDEST CHURCH IN TOWN. In 1885, Dr. James Gillespie, George Stocking, and Jeremiah Murphy contracted with James Chaplen for the building of St. Paul's Protestant Episcopal Church, unpainted and unfurnished, for $870. Ground was broken August 20, the building was under roof October 11, 1885, and March 13, 1886, saw the first Lenten service. The bell in the tower has this inscription: "M. C. Shane Baltimore, Md. 1894." (Thistle.)

FIRST BAPTIST CHURCH. Men line the wrought-iron fence of the First Baptist Church yard at Diamond and Wells Streets. Built in 1838 on a lot donated by the William Russell family, the quaint building stood for 56 years. In 1894, the congregation erected a new church. The large, ornate brick building was constructed on the same site but stood only 16 years. (McCoy.)

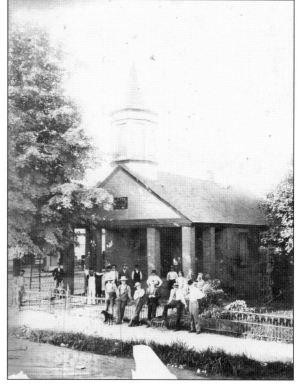

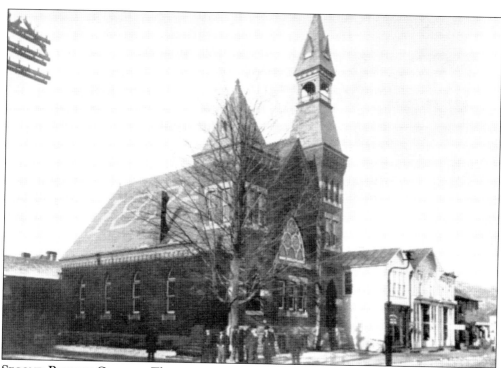

SECOND BAPTIST CHURCH. The second Baptist church gave way to demolition in 1910, when the current church was built. The bell, which occupied the unique high bell tower, was saved because it had been purchased by popular subscription. The city moved the bell to a steel derrick alongside the set of concrete stairs leading to McCoy Heights, where it served as a fire alarm and curfew bell for many years. (Thistle.)

THIRD BAPTIST CHURCH. After giving up the prior building at the corner of Diamond and Wells Streets to demolition, the Baptist congregation rebuilt two blocks north at the Hill Street corner. This gold brick church, which serves the current congregation, was built in 1911. The Baptists have had a presence in Tyler County since the 1830s, initially meeting in private homes. Main Street School is in the background. (McCoy.)

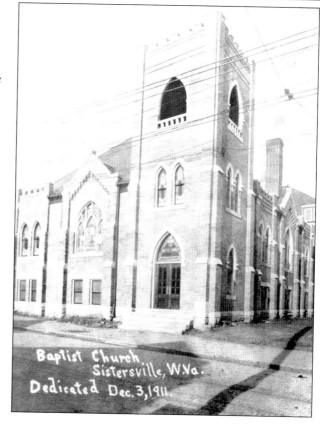

Baptist Church
Sistersville, W.Va.
Dedicated Dec. 3, 1911.

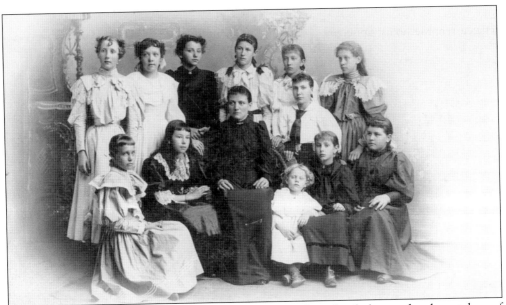

SUNDAY BEST. An 1895 Methodist Episcopal girls' Sunday school class under the tutelage of Dora Jergens posed with this decorative backdrop. From left to right are (first row) Minnie Withee, Mary McKisson, Dora Jergens, ? Sikes, Isla Cutler, and Bessie Varner; (second row) Jessie Fallwell, Lulu Snyder, May McKisson, Ira Salisbury, Emma Wise, Mabel Chatterdon, and Bertha Sikes. (McCoy.)

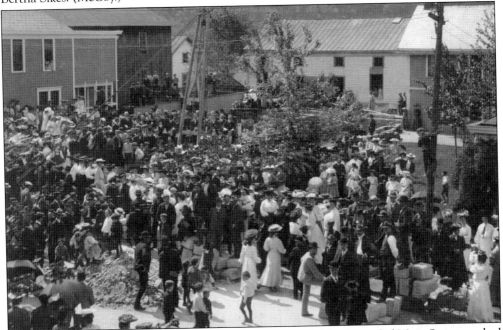

A STRONG FOUNDATION. Hundreds of men, women, and children crowded Main Street, packed surrounding buildings, and even climbed poles to watch the cornerstone-laying ceremony for the new Methodist Episcopal church in 1906. The local Masonic brotherhood is overseeing the ceremony, signified by the banner gracing the crane at the center of the photograph. Notice the limestone blocks lining the sidewalk. (McCoy.)

50

METHODIST EPISCOPAL CHURCH.
The current Methodist Episcopal church, located on the west side of Main Street between Diamond and Elizabeth Streets, was completed in 1905. Several additions have been completed in recent years, adding classroom, meeting, and event space, but the robust towers and large stained-glass windows have always made it one of the more impressive structures in Sistersville. (McCoy.)

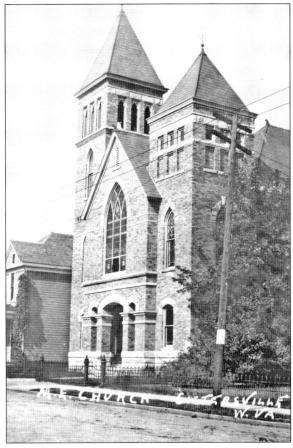

BRIGHT MINDS, SUNNY DAY.
Attendees of the 1908 Tyler County Teachers Institute took advantage of the three-year-old Methodist church to pose for a photograph on this bright August day. Notice the teacher near the window at the right, playfully screening a bald gentleman's head from the sun using her hand. Many of these teachers would have still taught in one-room country schoolhouses. (McCoy.)

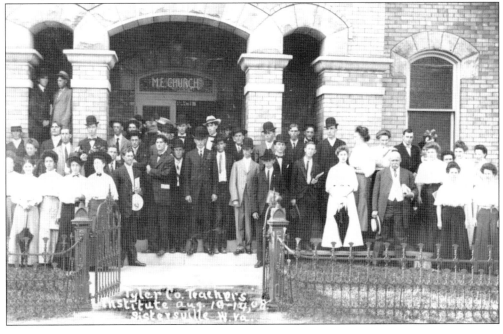

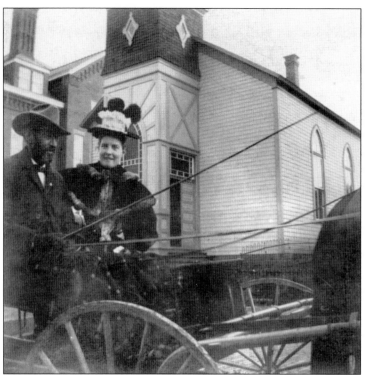

FATHERS DAY. Ephraim Wells, builder of the Wells Inn, and his daughter, Blanche Wells-Kinkaid, travel in front of Holy Rosary Catholic Church and the Main Street School by horse and buggy. They were the grandson and great-granddaughter of Charles Wells. Notice that a bell tower has been added at the entrance to the church. (McCoy.)

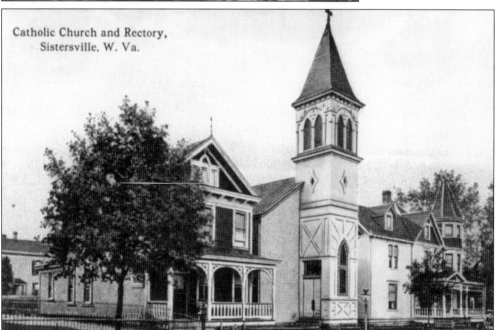

Catholic Church and Rectory, Sistersville, W. Va.

HOLY ROSARY. The history of Holy Rosary Catholic Church goes back to 1893, when Fr. Adeodatus Boutlou of Moundsville established a small mission. The present church was built in 1894. In 1895, Fr. Robert O'Kane came to Sistersville. Fr. Patrick Boyce became the first pastor in 1898 and served until 1923. The church was damaged by fire on January 27, 1950, and remodeled; the current rectory is at right. (McCoy.)

NAZARENE CHURCH. The Church of the Nazarene, located on the west side of Wells Street, was built as the Presbyterian church in 1896. Presbyterian churches were previously built in 1845 and 1889 on the same lot donated by Sarah (Wells) McCoy, daughter of Charles Wells. The Nazarene church members purchased this building in 1946, doing extensive remodeling and making repairs to the building. (Thistle.)

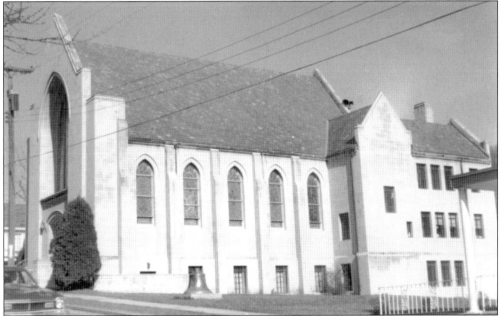

ART GLASS. The new Presbyterian church, with windows from Tiffany's New York, had the cornerstone laid July 12, 1931, and was dedicated October 7, 1934. The bell from the third Presbyterian church, pictured above, was placed in the yard of the new church at Charles and Chelsea Streets. It is inscribed "1st Presbyterian Church 1897 by McNeely and Company, West Troy, NY 1897." (Thistle.)

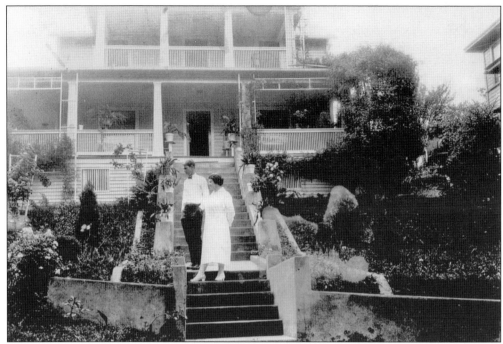

HEALING WATER. After moving from Wells Street, the William West home at 613 Water Street served as the second location of Sistersville General Hospital from 1911 to 1913, until flooding necessitated a move. The lovely, garden-like terraces led down to the street, which was closer to the Ohio River at this time. This house still stands and was a hotel after serving as a hospital. (McCoy.)

BROADENING THE WAY. This picture shows Sistersville General Hospital after a street-widening project for Water Street with a doctor, nurses, and a child posing on the remodeled porch. The former Sam Langham residence is at left. The hospital moved to the S. G. Cline property on East Street, then to the corner of Wood Street and Cemetery Hill Road for nine years, and finally to the current location on South Wells Street in 1928, becoming a city hospital in 1952. (McCoy.)

SPEEDY DELIVERY. The City Building, built on a lot designed for a courthouse, has served many government purposes over the years. In 1909, it served as a post office along with housing city government and the jail. Postal clerks pictured here are, from left to right, D. L. S., assistant postmaster; Edith Martin, clerk; and Margaret Kelly, money orders and registered mail. (McCoy.)

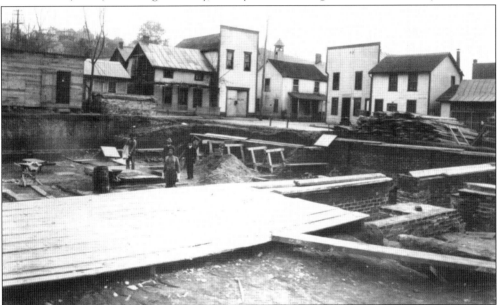

THANK UNCLE SAM. The current Sistersville Post Office at the corner of Wells and Elizabeth Streets was built in 1913, becoming the first federal building ever built in Tyler County. Notice the Ephraim Wells Hook and Ladder Building in the center of Elizabeth Street and the bell tower of the new, larger J. T. Jones Hose Company in the background. The railroad ran behind the two buildings. (McCoy.)

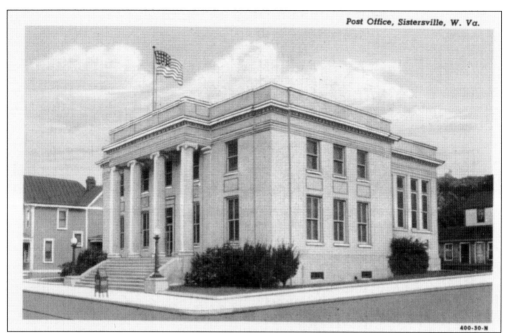

Post Office, Sistersville, W. Va.

400-30-N

FIRST-CLASS MAIL. This postcard of the Sistersville Post Office shows the monument-like structure that sits at what is today Sistersville's busiest intersection. The interior lobby and customer boxes are ornate, with brass and wood features throughout. The building that houses the Veterans of Foreign Wars, Coe-Thorn Post, is seen just to the left of the post office. (McCoy.)

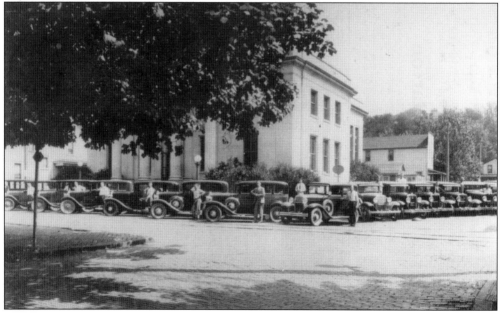

HOT RIDES. Employees of the Sistersville Post Office display their handsome fleet of mail delivery vehicles on Wells and Elizabeth Streets. When the first post office started in April 1819, the postmaster was Joshua Russell of Pole Cat Run fame, and the mail route was established from Clarksburg by way of the Tyler County Courthouse. Mail arrived only once a week and was carried by packhorse. (McCoy.)

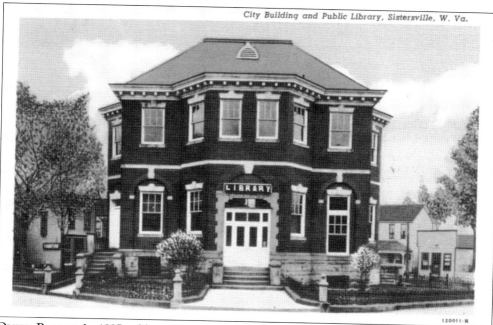

QUIET PLEASE. In 1897, a library was started in the office of the Main Street School with 50 books. In 1900, the number of books had more than doubled after many books, including the *Encyclopedia Britannica*, were purchased with money contributed by the pupils. This postcard reveals the location of the first Sistersville public library in Sistersville, when Bertha ("Bert") Chadderdon was librarian, assisted by Elsie Stealey. (McCoy.)

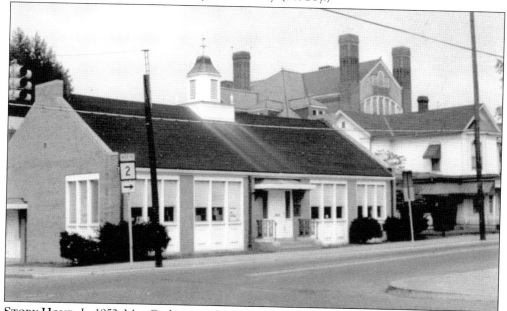

STORY HOUR. In 1952, Mae Corbitt gave her house and lot across from the post office to the City of Sistersville for use as a library. The house was torn down and the present Sistersville Library was built in 1964. Bert Chadderdon was the first librarian in the new building until her death in 1966, Ruth Lillequist served until 1968, Dorothy Harsha retired in 1976, and Connie Snodgrass became librarian in 1977. (Thistle.)

TALL DRINK OF WATER. With such a large population and the wealth of the community, Sistersville was able to build reservoirs on Cemetery Hill, as pictured in 1906, to supply water for drinking, cooking, and plumbing. Water from the river would be treated and pumped into the tanks. Sistersville is now one of only two communities to still draw water from the Ohio. (McCoy.)

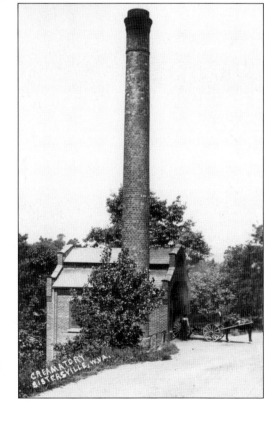

WASTE NOT, WANT NOT. Trash and waste were an immediate issue when Sistersville's population increased by thousands over a few years. The crematory on Old State Route 18 above Happy Hollow was used to burn garbage and waste and helped keep up Sistersville's reputation of being a very clean city. The building but not the smokestack still stands today. (Thistle.)

Four

AMUSEMENTS, WARS, AND SOCIETY

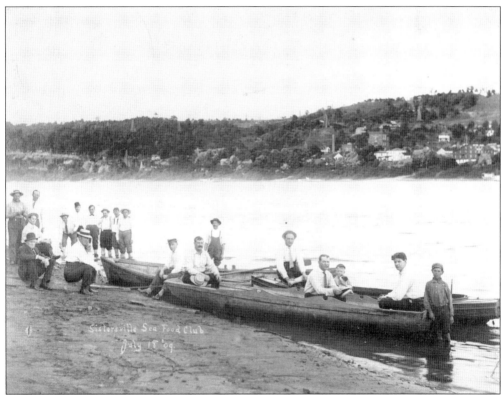

CATCH OF THE DAY. This unique photograph shows the Sistersville Sea Food Club posing in their wooden rowboats along the Ohio shore on July 18, 1909. The Ohio River, Iroquois for "good" or "great" river, has long drawn use for travel, industry, and recreation such as swimming, boating, and fishing. The Sistersville Brewery building and Riverside Mills are visible on the West Virginia shore. (McCoy.)

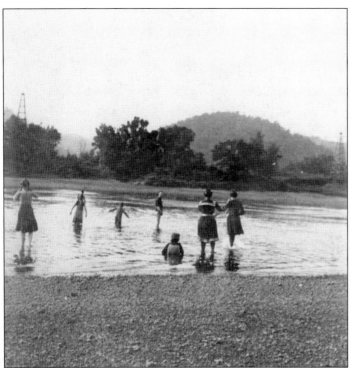

WADE IN THE WATER. Summer often brought low water to the valley, which could hinder boat traffic; however, the Sistersville ferryboat has never had to cease operation because of low water. These swimmers are enjoying the shallow depths near the present-day city park. The photographer is looking from the Ohio side. (McCoy.)

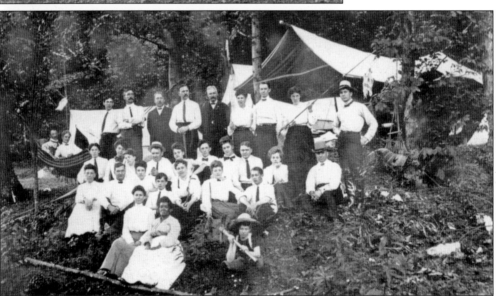

LIFE IS A PICNIC. Camping along the Ohio River was quite popular, as seen with this group at their camp across the river from Paden City in 1904. From left to right are (in the hammock) Charlie Grier and Dude Graham; (first row) Romaine Elliot, Carrie Carter, and Charley West; (second row) Mrs. ? French, Henry McCoy, Genevieve Chestnut, Bill Stathers, Mrs. ? Durham, Hattie Young, and Dick Elliot; (third row) Annie Elliot, Lucy Rayme, Maude Lawrence, Dr. ? Jennings, Jeanette Young, Ralph Devore, Elizabeth Gaffney, Walter Bishop, Sadie Wallace, and Lynn Kirkland; (fourth row) Clyde Devore, Ed Wallace, A. C. Jackson, E. A. Durham, Frank French, Meta West, John McKay, Sarah Agnew, and Dr. Jim Stathers. (McCoy.)

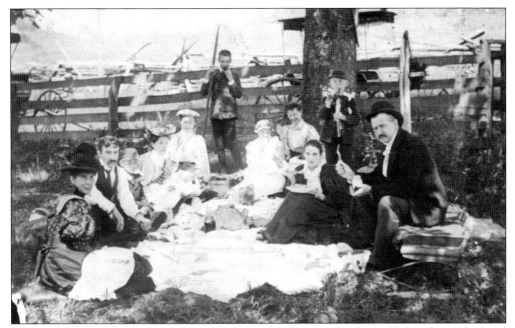

COOLER IN THE COUNTRY. Tyler County's beautiful countryside often called to those who lived in the busier town of Sistersville. Here are the J. Hanford and George M. McCoy families having a picnic near Middlebourne in 1896. Notice the canopied wagon from which George McCoy has removed the seat for his own use. (McCoy.)

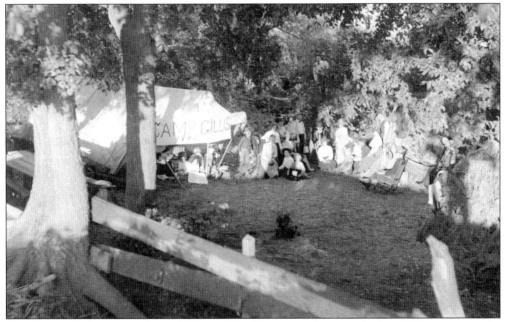

THE GRASS IS GREENER. Camp Gillis in Tyler County, as photographed in 1902, was a popular camping and relaxation spot. The agrarian, peaceful nature of Tyler County was a draw for many residents who had come from bigger cities. The Tyler County Fair, held each August at the fairgrounds near Middlebourne, offers a reminder of that agrarian heritage along with all the excitement of carnival rides, live entertainment, and dirt-track auto racing. (McCoy.)

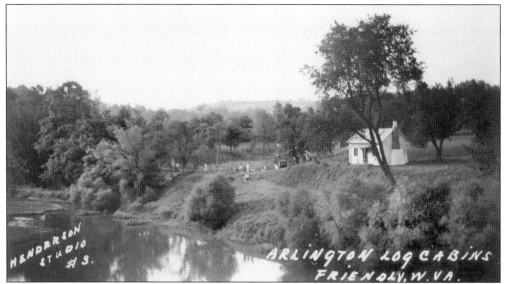

FRIENDLY CONFINES. This lush and peaceful scene shows Arlington Log Cabins in the hills behind Friendly. Middle Island Creek, the longest stream in West Virginia to be called a creek at around 77 miles, is in the foreground. It is Tyler County's major waterway besides the Ohio River and empties into the Middle Island channel of the Ohio at St. Mary's, Pleasants County. Middle Island Creek is famous for muskellunge fishing and for "The Jug," a seven-mile meander where the stream returns to within 100 feet of itself. (McCoy.)

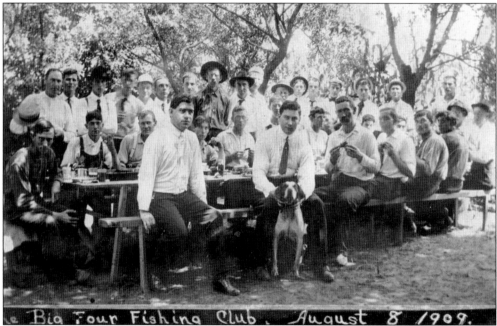

BIG FOUR FISHING CLUB. Carter Oil Company sponsored this group, which includes Thurman Durff, Mike Kelly, Jimmy O'Brien, ? Spencer, Tom Bell, Jack Fitzgerald, Bob Lock, Leon Fleming, Fred Appel (who owned the grocery store at the corner of South Wells and Urban Avenue), Homer Dudley, Russ Beaver, Lou Boyer, Jim Selmon, Ross Bowen, Bill Gregg, Bill Hall, Jim Bowen, Jack Stroups, Dick Evans, and Cain Baker. (McCoy.)

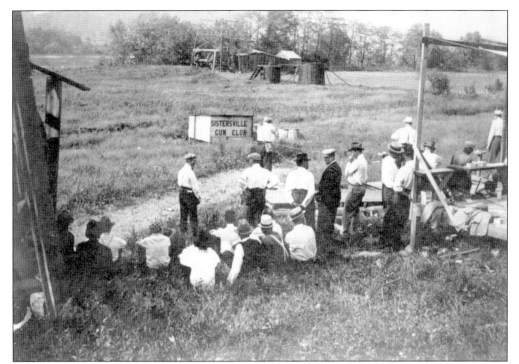

READY, AIM, FIRE. The Sistersville Gun Club was an option for hunting and firearms enthusiasts who could not make it out to the hunting grounds. The river-bottom shooting range south of Florida Street provided a safe backdrop for shooting skeet and taking target practice. The SHS football field is on the right in this *c.* 1910 photograph. (McCoy.)

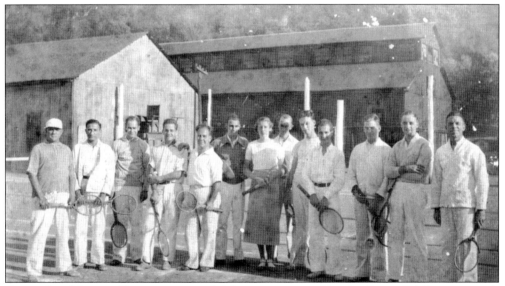

GAME, SET, MATCH. Tennis was a coed club sport sponsored by the Carter Oil Company with teams made up of employees. These courts were built near the Carter works along the Baltimore and Ohio Railroad tracks. Acquaintances formed through sports led to social bonds and exercise that improved the health and morale of workers. (McCoy.)

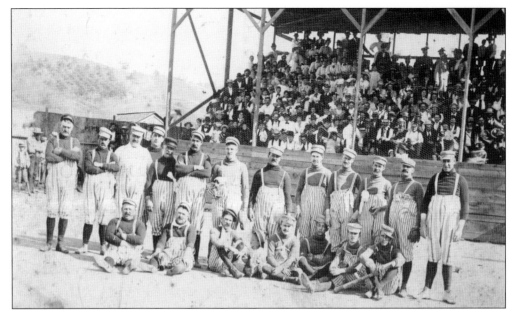

AMERICA'S PASTIME. Large crowds would gather to watch local teams of adults and semiprofessionals play baseball at diamonds in Sistersville or at Paden Park at the southern end of Paden City. Colorful uniforms, a pep band such as the one seen here in the stands at the right, and maybe some Cracker Jacks made for classic American entertainment. In 1915, Sistersville played a home game against the Pittsburgh Pirates. (McCoy.)

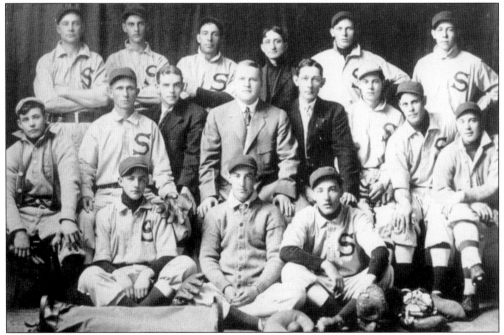

BOYS OF SUMMER. Here is the 1910 Sistersville High School baseball team, in no particular order: F. Culp, Chalk Flading, Bert Sapp, Friend Willows, Frank Gaffney, Harry Carpenter, Chuck Ward, Frank Martin, Art Doyle, Phill Messer, Ross Tischer, Bud Tischer, Jess Bracey, Karl Zinn, Frank Roome, and Poo William. (McCoy.)

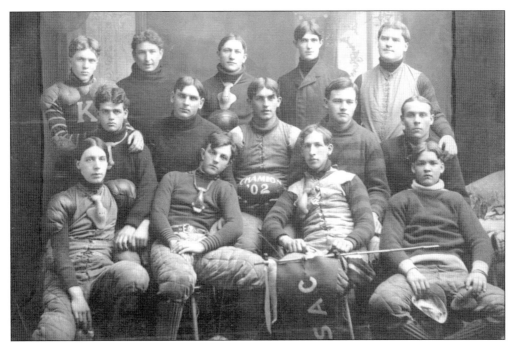

ROUGH AND READY. This 1902 football team holds a ball reading "chamion" and a banner for the S.A.C. While Magnolia was more competitive against the Tigers, the Tyler Red Raiders were bitter rivals with Sistersville for years. The two Tyler County high schools combined in 1993 to form a new school with the nickname Silver Knights. Knights may have been the nickname for this team as well. (Thistle.)

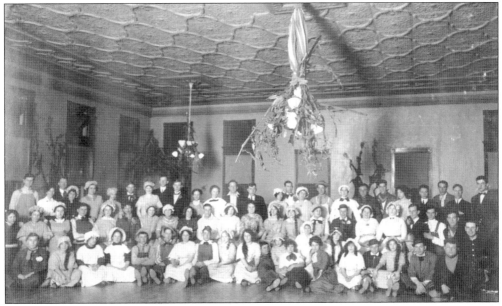

DANCE THE NIGHT AWAY. Dances were popular entertainment for young people in Sistersville and usually featured a local band. There were several locations around town with proper dance halls and space for balls. This Carnation and Cotillion Club Party was held in the upstairs of the Thistle Building. (McCoy.)

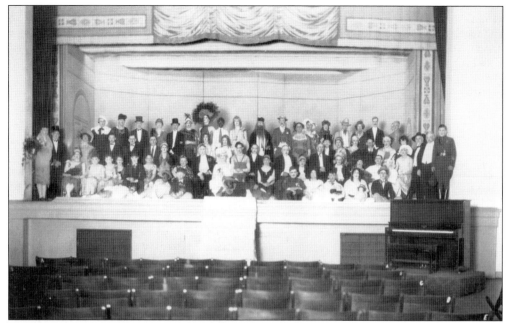

HANDSOME LADIES. This cast of players for a skit called *Womanless Wedding* is gathered on the stage of the Sistersville High School gymnasium-auditorium for a group shot. Such skits were usually done as fund-raisers and often poked fun at a prominent male citizen who, to the surprise of the audience, ended up being the bride. (McCoy.)

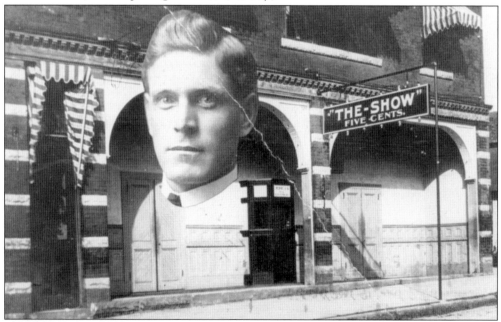

HOLLYWOOD AT THE HENAGHAN. The Show was located on the east side of Charles Street at the corner of Alley C in the rear of the Henaghan-Daly Building before eventually becoming the Paramount Theater. In 1909, it was all silent movies, and the price of admission was only 5¢. The gentleman inset is the theater manager, a Mr. Langworthy. He was in charge of the Show for several years. (Thistle.)

HAMMING IT UP. "Noisy" Sperry (left) and George Gilbert pose in front of an advertisement at the opera house for the 1917 Broadway musical comedy *Oh Boy*. It featured music by Jerome Kern and lyrics by P. G. Wodehouse. A notable song that would have been heard at the show was "Till the Clouds Roll By." (McCoy.)

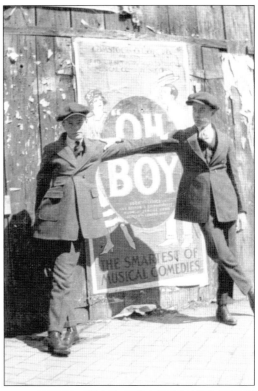

CLOWNING AROUND. This image is from a program used at the Columbia Theater in Sistersville around 1900. The grand Sistersville Opera House and the other theaters in town were main stopping points for entertainment traveling the Pittsburgh-to-Cincinnati circuit. John Phillip Sousa played the opera house on Thursday, September 10, 1903, during his band's summer tour. (McCoy.)

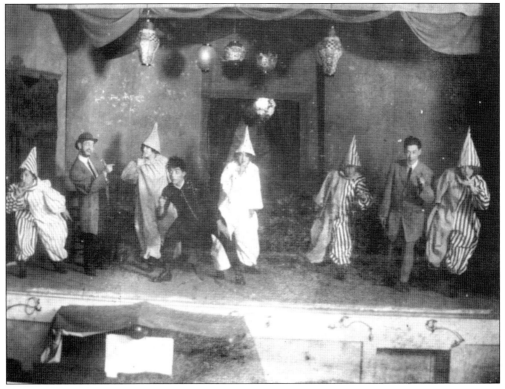

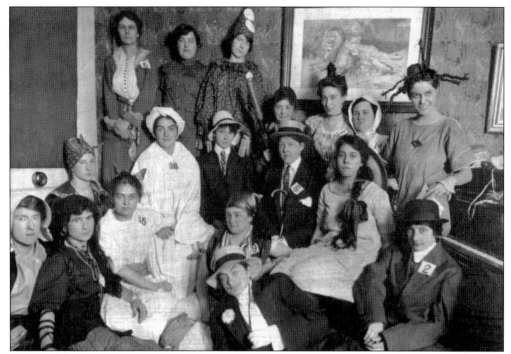

TALENTED TROUPE. This group of performers and actors, which may be all female, made up the cast of one of the many shows to be featured at the Sistersville Opera House. Note the rich detailed wallpaper and exotic lion painting on the wall. Some shows came to Sistersville directly after leaving New York's theaters and occasionally featured the biggest stage stars of the day. (McCoy.)

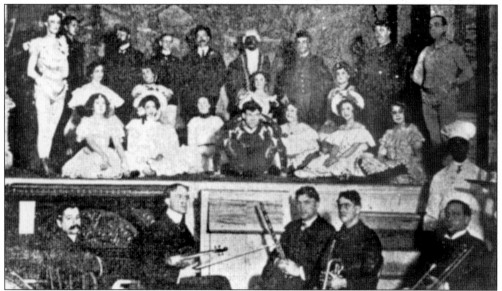

THE COLUMBIA THEATER. Known as the Comique in 1897, the Columbia was located at Charles Street and Alley A. The Columbia Café, located at Charles and Water Streets, at one time offered a 5¢ glass of beer, which included a ticket to the theater. A 1902 cast member, Ben Turpin, later was a movie actor. Members of the orchestra are identified as Clem Polen, George "Boney" Still, and Harry Kepner. (Thistle.)

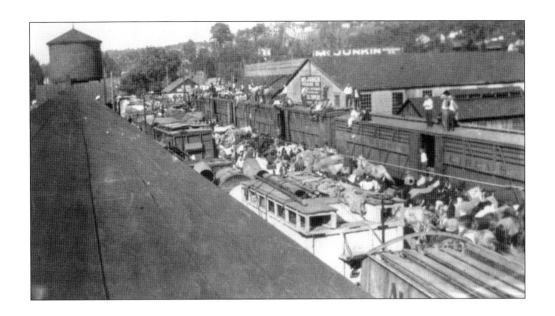

GRAND CENTRAL STATION. The 1920 Barnes Circus is unloading for the parade around Sistersville to the riverside or the park, where the circus tents would be set up. The B&O train station was an exciting place in Sistersville when the circus or any other major event arrived in town. Notice in the top picture the men standing on top of the rail cars (the McJunkin Machine Shop is in the background) and in the bottom picture the huge number of horses. (Thistle.)

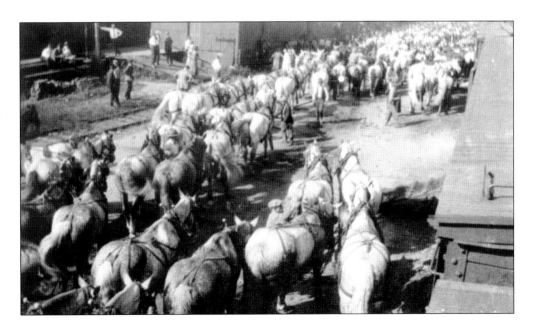

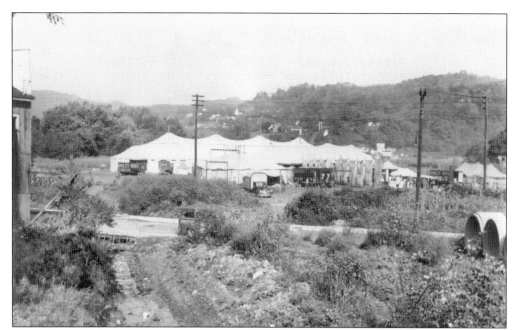

COME ONE, COME ALL. The Dailey Brothers Circus was at Sistersville in September 1945. The circus returned in 1947 and again set up in the current City Park. Looking down from Chelsea (formerly Brown Betty) Street over McCoy Street, there is a lot of corn growing around the grounds, and the outdoor trapeze is ready for the coming show. (Thistle.)

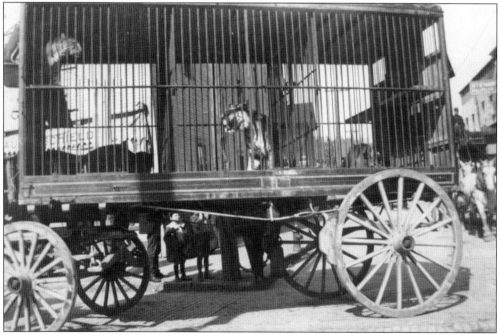

TIGER TOWN. On September 30, 1903, the Adam Forpaugh Circus wowed the crowds of children and adults with a caged tiger, lion, and jaguar parading through town. The circus parade is making the turn from Hill Street to go south on Wells Street in this picture. Notice the little boy looking up from the curb just below the wagon. (Thistle.)

70

KIDS AT HEART. Sistersville's citizens have always come out for parades and holidays. The annual Halloween parade, where children like these 1911 ghouls gather, is held on Wells Street for costume judging before kids take to the neighborhoods for trick-or-treating. Above right, three Beni Kedem Shriners, identified only as a lawyer, a surgeon, and an undertaker, entertain some kids in the summer of 1910. (McCoy.)

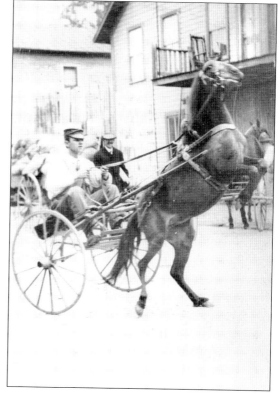

HERE COMES TOPSY. Evart Thistle shows off his trick pony to Ben Shriver (left) and Tom Gill in front of the old H. S. Hardenberg Livery Stable on Brown Betty Street. Karl's Esso was built on the same lot in 1968. Hardenberg had two barns in Sistersville and one across the Ohio River opposite Sistersville. At one time, he had 47 horses for hire and 25 boarding horses. (McCoy.)

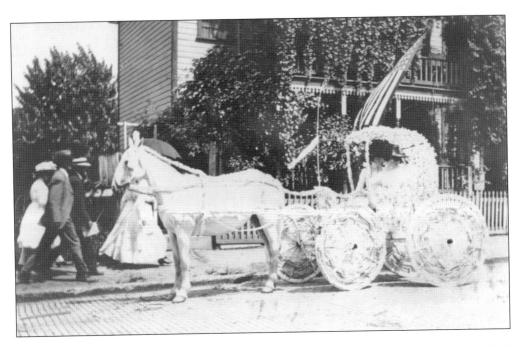

FAIRY-TALE CARRIAGE. The intricate flower decorations on this horse and carriage won Nell Burns and her sister second place in the 1908 Fourth of July parade in Sistersville. The carriage is parked on Main Street, where passersby continue to admire the work of the young girls. Parades were also important to businesspeople who wanted to impress people and show their community dedication. Below, the Tyler Hardware float taking part in the 1911 Fourth of July parade is a rolling advertisement. The bunting and colorful lettering catches a patriotic eye, while children play with and demonstrate a new stove being hauled on the float. (McCoy.)

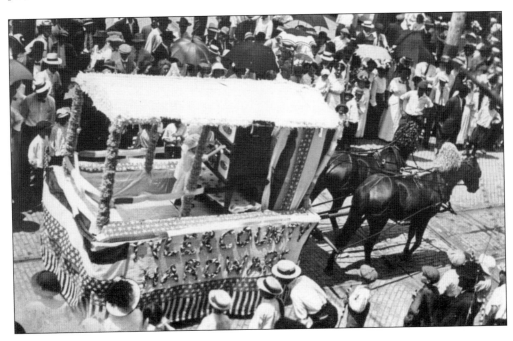

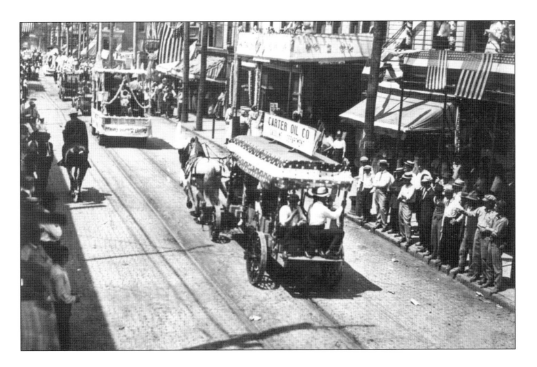

ROLL OUT OLD GLORY. The Fourth of July really saw Sistersville decorated to the hilt with flags, banners, and bunting draped over every balcony, windowsill, and wire above the street. In the 1909 parade, a Carter Oil Company Gasoline Plant float puts some refinery workers at center stage heading south on Wells Street. In the photograph below, the intersection of Wells and Diamond Streets is packed with onlookers awaiting the parade. The second Baptist church, the Farmers and Producers National Bank building, and the Peoples National Bank building are decorated, with the Peoples building showing a flag with a cross and crown. (McCoy.)

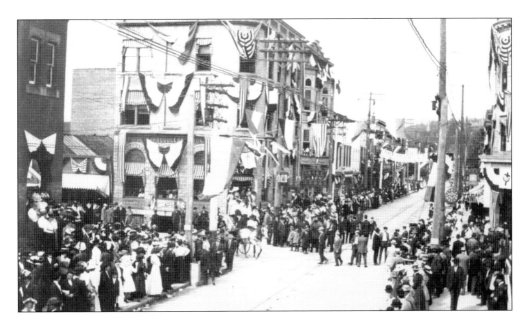

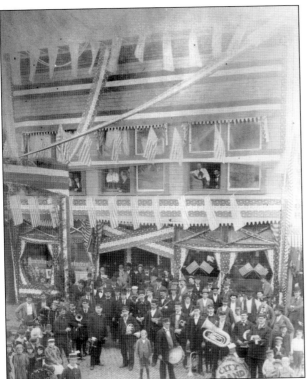

STRIKE UP THE BAND. The Manhattan Club and Restaurant looks practically gift-wrapped for Independence Day as the City Band prepares to strike up a tune on Wells Street in 1896. Children await the music, while men in windows and on bicycles look on eagerly. When recorded music was scarce, it was always important to have a quality brass band or marching band on hand for big events. (McCoy.)

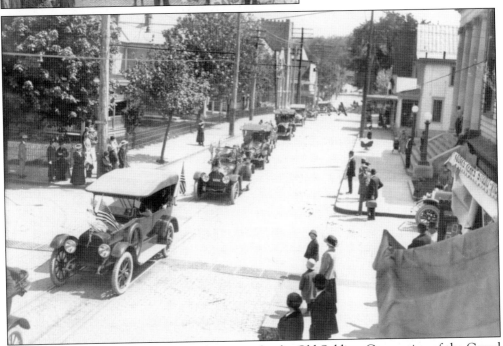

GAR CARS. These automobiles line the streets for the Old Soldiers Convention of the Grand Army of the Republic (GAR) in Sistersville. The property that Mae Corbitt donated for the public library can be seen at left, across from the post office. The current Baptist church is visible on Wells Street at Hill Street. (McCoy.)

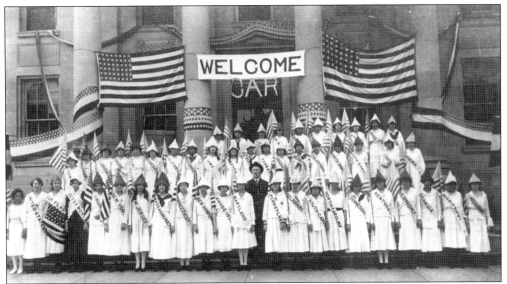

A CIVIL DISPLAY. The Old Soldiers Convention of 1915 was a celebration for Union army war veterans. During the Civil War, the sentiment of the people of Sistersville was divided between North and South. Before the war, a company organized and called itself the Sistersville Blues. Some ladies in town made the flag shown below, which is at the Tyler County Museum. Most of the men in the Blues Company were over 6 feet tall. The Union sympathizers organized a drum corps for the Union, but the Confederate sympathizers displayed a Confederate flag, hiding it in the walls of one of their houses. Founded by Benjamin F. Stephenson on April 6, 1866, in Decatur, Illinois, the GAR was among the first interest groups in American politics. Its organization was based partly on the traditions of Freemasonry and partly on military tradition. (Above, author; below, McCoy.)

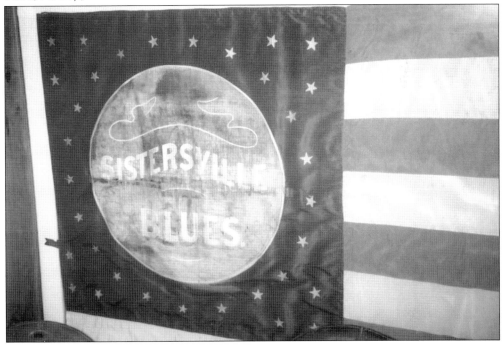

BERLIN OR BUST. Men of Company B, 1st Provincial Recruit Battalion leaving for World War I are, from left to right, Arch Boyd, Art Case, Jim Frame, Emmit Hill, Howard Erwin, Ray Weber, Albert Sater, Karl Krug, Art Doyle, Dr. ? Turner, Poppy Richards, and John Schuler. (McCoy.)

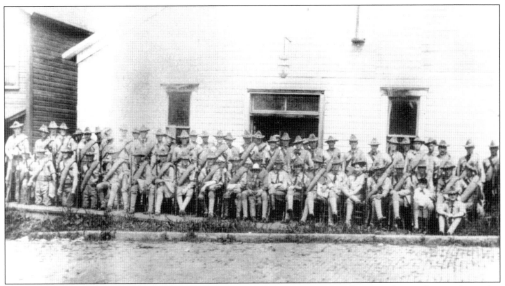

ON GUARD. The West Virginia National Guard Armory, pictured in 1905, was located on the west side of Brown Betty Street. The building extended from Brown Betty to Alley C by the Wells Inn. An office was in the east corner fronting Brown Betty, and an outside stairway at the rear of the building led to a small room. After the National Guard was dismantled, the building was used for a roller rink. Evart Thistle had a livery and boarding stable in the building from 1911 to 1913. (Thistle.)

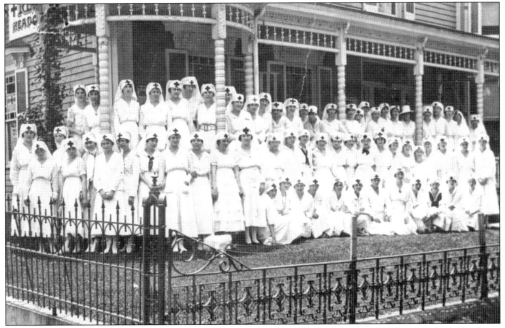

THE WAR AT HOME. This group of all-female Red Cross workers looks proud to support the boys serving in World War I. The Red Cross headquarters was in the W. J. Neuenschwander home on the corner of Wells and Charles Streets, defined by its elaborate wrought-iron fence. The house and fence remain in fine condition, though the porch with its intricate spindle work has been removed. (Thistle.)

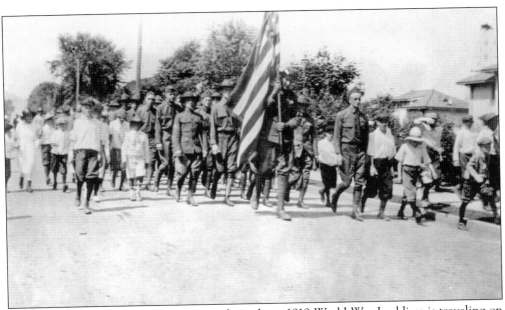

THE BOYS GO MARCHING. This group of marching 1919 World War I soldiers is traveling on South Wells Street behind the Neuenschwander house. Like West Virginia as a state, Tyler County has a long history of volunteering for military service but also contributed to the war effort by producing gasoline and fabricated metal for ships, bombs, and tanks. (McCoy.)

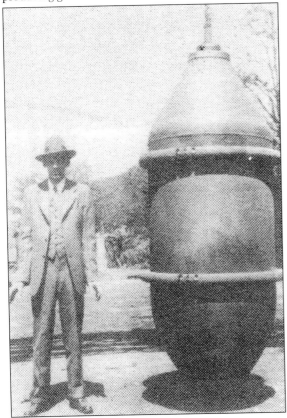

BOMB'S AWAY. Henry McCoy Sr., former Sistersville Tank Works owner, poses beside a "Block Buster" bomb casing prior to its shipment to the U.S. military. Sistersville Tank aided the war effort by producing specialized bomb casings during World War II. The Block Busters were designed expressly for use against Nazi submarine pens or bunkers. Sistersville Tank Works remains an industry leader. (Vincent.)

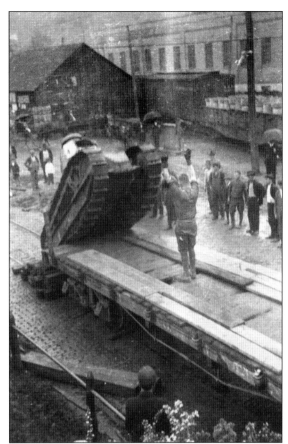

TRICKY TANK. The government would often bring military equipment to towns in order to stage rallies for selling bonds and earning money for the war bill. This U.S. tank was unloading from a rail car at a rally to sell liberty bonds behind the B&O station in 1918 when it tumbled off the logs at the end of the rail car and onto its side. This may have drawn more of a crowd than anything else. Luckily the occupant of the tank was uninjured. (McCoy.)

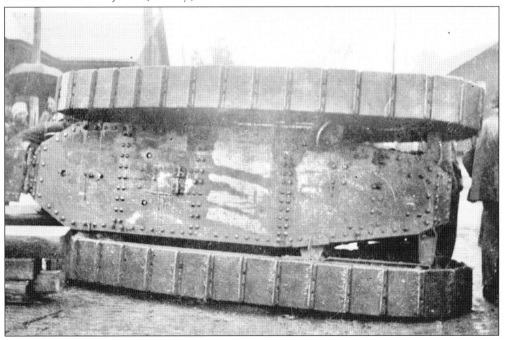

NOT HORSING AROUND. Women of Sistersville had a variety of clothing stores to shop in during the oil boom days, and these women may have come from out of town to take advantage of the fine selection and service available from Sistersville merchants. Train and trolley offered easy access from the surrounding area of Tyler, Wetzel, and Pleasants Counties. There was a millinery located on McCoy Street for many years, which may be where these ladies found their decorative hats. (McCoy.)

DRIVE MY CAR. This group might be waiting for the ferry to pull up to Catherine Street and take them across the river to Fly, Monroe County. Automobiles changed the way people thought about travel and opened the countryside to the sometimes-noisy, dust-spewing cars that tore up dirt roads. The 1840s brick buildings in the background were still in use, but only the Russell building to the rear still survives. (McCoy.)

THE GOOD LIFE. Dr. W. H. Young's residence—his wife and two daughters posing near the shaded porch with double porch swings—along with the image of him proudly sitting in his touring car give an indication of the kind of life that was afforded to a doctor in a busy town like Sistersville. Dealing in oil wasn't the only way to get rich; providing goods and services to a community that once had the greatest per capita population of millionaires in the United States still put that oil money in your pocket. (McCoy.)

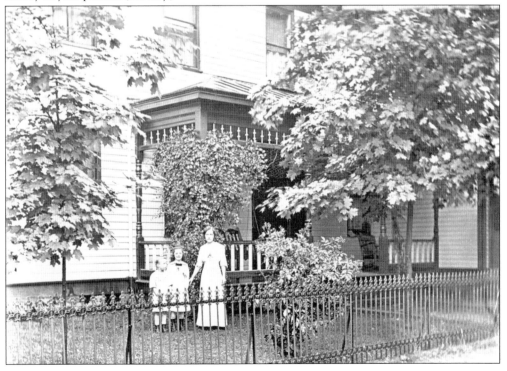

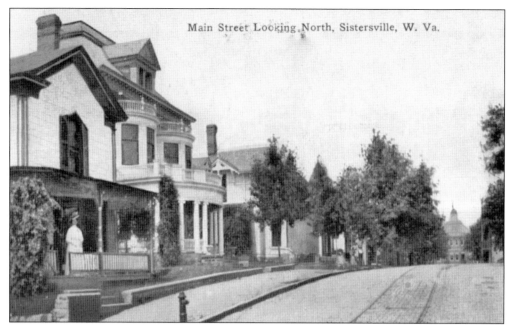

VICTORIAN GRACE AND CHARM. This 1903 picture of Main Street in Sistersville looking north shows some of the street's fine homes, including the Joseph G. McKay house with the white gingerbread, one of the oldest homes remaining on Main Street. Mrs. Fred Ryan is standing on the porch of a home that no longer stands. This McCoy's Bookstore postcard was sent to Mrs. William H. McKisson in Philadelphia, stating, "We pass up this street almost every day going to school." (McCoy.)

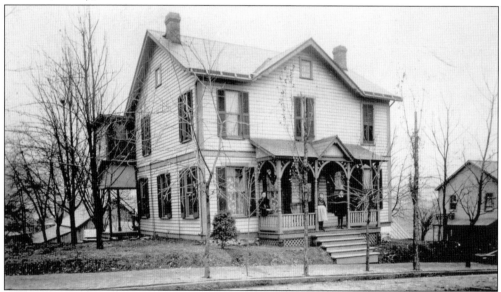

EDITOR IN CHIEF. J. Hanford McCoy (1856–1938) lived here at 823 Main Street with, from left to right, wife Susan Thistle Wells, daughter Nell Wells McCoy, and son Tom McCoy. He founded the *Daily Oil Review* in 1895 and cut loose an apprentice named Joe Williams in 1898, who went on to found, edit, and publish the *Pleasants Leader*. Tyler County native Roy Owens was another well-known Pleasants County newspaperman. (McCoy.)

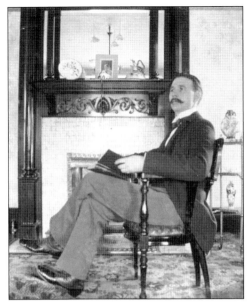

LORD AND LADY AT HOME. Edwin A. Durham and his wife, Ada, posed for these portraits in front of the same fireplace at their house on Main Street in Sistersville. E. A. Durham made money in almost every endeavor he invested in, including the oil industry, the Tyler County Bank, the First National Bank, real estate, and others. (McCoy.)

FOUR HORSEMEN. Astride their steeds in front of the E. A. Durham house on Main Street are some wealthy men of Sistersville. From left to right are Bland Wells, George Durham, E. A. Durham, and unidentified. Horseman's skills were socially important at the time for sport and some travel, even though the wealthy would typically be chauffeured around town. (McCoy.)

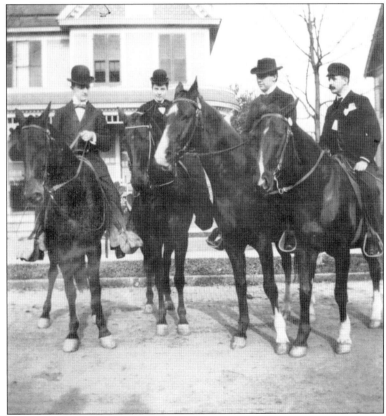

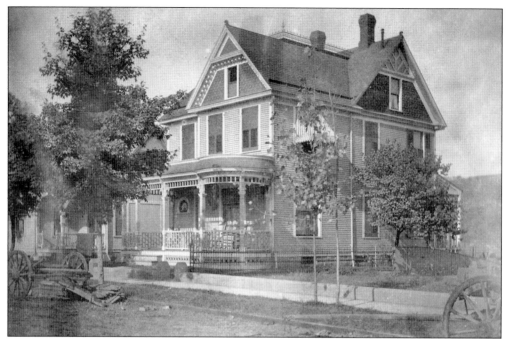

E. A. DURHAM HOUSE. The gorgeously appointed E. A. Durham house at 808 Main Street is now hidden behind some modern remodeling and an upper sunroom. The stained-glass window to the left of the porch is still recognizable. The Durhams moved into the house below, located on Millionaires' Row in Gary Owen. (McCoy.)

NOW THAT'S ITALIAN. Legend has it that E. A. and Ada Durham collected the different aspects of this beautiful Italian Renaissance mansion on Chelsea Street while on their honeymoon vacation to Italy. They searched the countryside over for the marble, stonework, glass, fine bronze, and ironwork and returned home to commission architect Edward Franvheim of Wheeling to build them the perfect home to display all they had bought. The results landed the home on the National Register of Historic Places. (Author.)

THE REAL McCOY. W. J. McCoy left a mark on Tyler County as big as the family name. Besides being the builder of the "Big Moses" gas well, he was a major investor in First Tyler Bank and Trust, Paden City Glass Manufacturing Company, Reno Oil Company, and Sistersville Tank and Boiler Works. As owner of Virginia Terrace and developer of Hanford City, he was the largest landowner in Tyler County upon his death in 1954. (McCoy.)

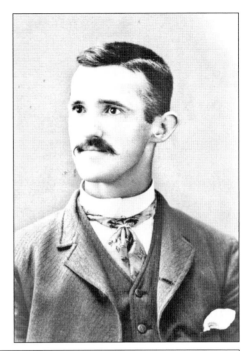

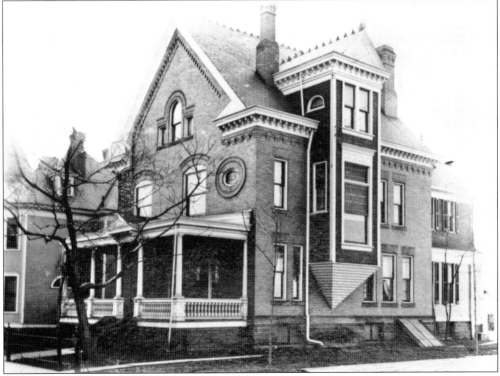

YELLOW BRICK HOME. W. J. McCoy built this Victorian home on Main Street in a grand yellow brick with amazing details in wood, glass, and brick. The home still stands out as one of the most unique in Sistersville. The home at left was the office of Dr. Elliot Thrasher for many years and was, until recently, the Townhouse Gallery. (McCoy.)

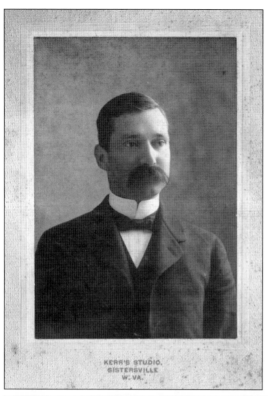

A LIFE WELL LIVED. Henry Woodson McCoy lived with his grandmother Sarah McCoy, who raised him like his mother at the Thistle house. He died young and unmarried after becoming involved in various Sistersville business ventures, including founding the Farmers and Producers Bank and the Tyler Traction Company. (McCoy.)

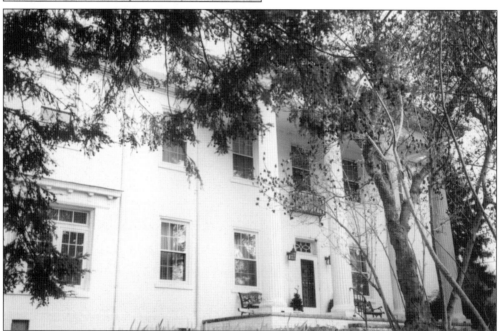

THISTLE HOUSE. This Greek Revival–style home was built by the Thistle family at the corner of McCoy Street and Thistle Avenue using many different interior features, such as an extensive use of interior light unusual for its day. The home overlooks the current city park and the Ohio River with the main entrance facing west. An original wrought-iron fence lines the property. (Author.)

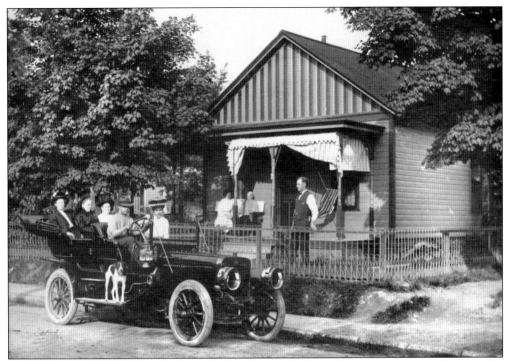

SUNDAY DRIVE. Perhaps setting out for a ride in the country, this car is parked in front of the Tim Cushing house on South Wells Street. It sat on part of the property between South Wells and Chelsea Streets where the Neuenschwander house (below) now stands. Though neatly kept and painted with a fenced yard, this house was probably built as one of the oil shacks or company homes common through the Gary Owen section of Sistersville. Based on its shape, size, and location, several such homes would have been demolished to make room for the Durham and Neuenschwander homes, which take up this entire square block. (Above, McCoy; below, author.)

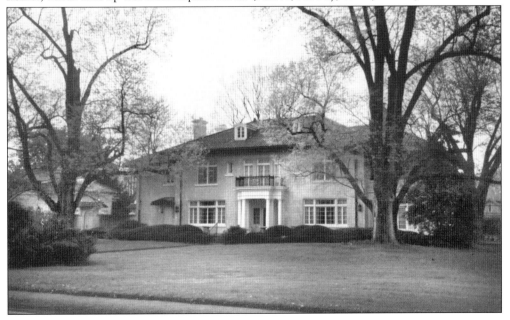

GARY OWEN. The Gary Owen section of town, extending from Thistle Avenue to the country club and from the base of the hill to the Ohio River, was actually not part of Sistersville initially. This area grew with company houses of the Carter Oil Yards along the railroad. It is also home to Millionaires' Row and eventually grew to feature many other fine homes. Chelsea Street, once known as Brown Betty, acts as the main thoroughfare through the southern end of town. (McCoy.)

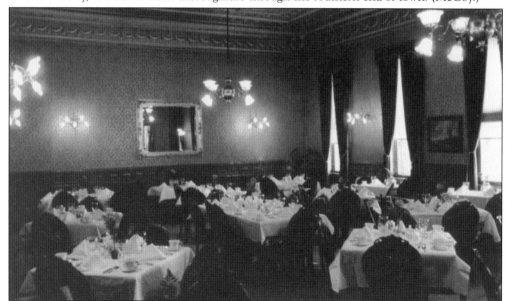

DINING IN ELEGANCE. The Wells Inn dining room in more recent times still holds up to the former splendor it held when built by Ephraim Wells. It has been the scene of many fine parties, receptions, dances, and dinners. The Black Gold Room, in the west wing of the main floor, is a less formal room, often used for teas, breakfast, and meetings. The Wooden Derrick Pub in the basement has known feast and famine as a watering hole for the guests of the hotel and regular patrons since 1893. (Author.)

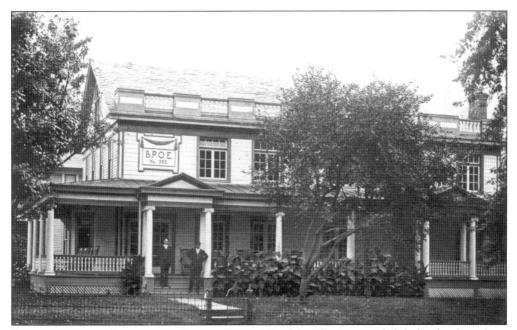

BENEVOLENT AND PROTECTIVE ORDER. BPOE 333 of the Elks is a social club that has been long established in Sistersville. The first Elks Club was organized in 1896. The building shown is still utilized by the Elks, but a brick building was added onto the eastern end, including a ballroom with stage and kitchen and the Riverboat Lounge downstairs. (McCoy.)

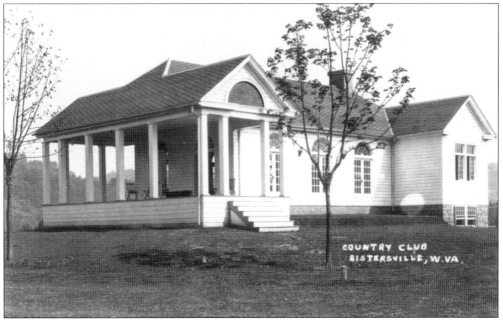

HIT THE LINKS. Sistersville Country Club was organized June 9, 1919. The first meetings were held in the Ephraim Wells home, vacated by Carter Oil Company. Forty-five to 46 acres of the Ephraim Wells farm were purchased and the clubhouse was built near the river in 1925. SHS won state golf championships in 1958 and 1959. The famed Sam Snead played in several tournaments here and is rumored to hold the course record. (McCoy.)

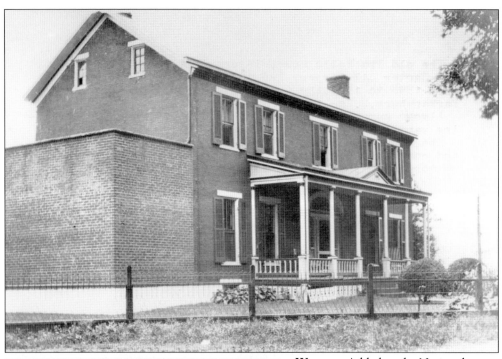

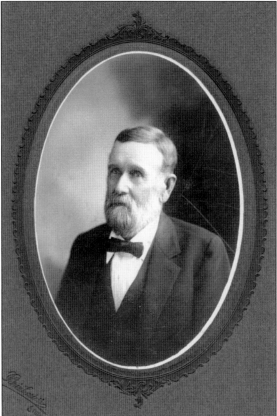

WELKIN. Added to the National Register in 1986, it is the site of the first Tyler County Court and an 1832 home built by Eli Wells, son of Charles Wells. The Carter Oil Company had their office in the building from 1898 to 1919, then moved to Parkersburg. The boxy addition contained the oil company vault, though it was removed when the house was restored by J. Wells Kinkaid, grandson of Ephraim Wells. (Thistle.)

EPHRAIM WELLS. As a grandson of original settler Charles Wells, Ephraim Wells was already local gentry. He had a fire company, a steam ferry, and his ancestral home all bearing his name, but his greatest accomplishment and contribution to Sistersville was the Wells Hotel, which he built and opened in 1893. Without such a grand house of hospitality, Sistersville wouldn't have earned the guest list of wealthy travelers who spent money and time in the theaters, shops, and casinos. His hotel added charm to Sistersville, tying his family history further into the fabric of the town. (McCoy.)

Five

TRAVELING
TYLER COUNTY

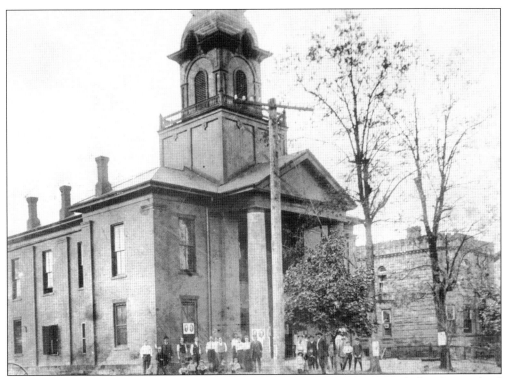

TYLER COUNTY COURTHOUSE. Upon the establishment of Tyler County out of Ohio County land on December 16, 1814, the first county court was held at Welkin in Sistersville. The legislature stepped in, naming Middlebourne as county seat because of its central location in the county. The county court met in several houses in town until the current courthouse seen above was built in 1854, with the jail and sheriff's residence to the right. The courthouse underwent extensive remodeling in 1922. (Tyler County Museum.)

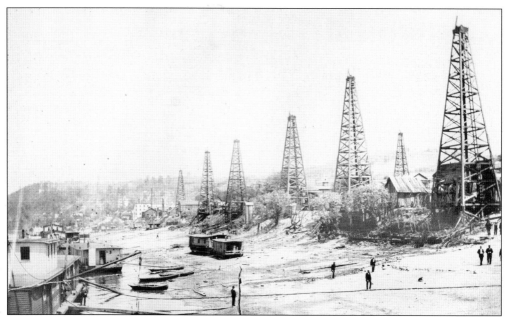

SISTERSVILLE WHARF. The tall derricks lining the shore give the town a fortress-like appearance in this 1893 view from the Sistersville wharf. The wharf boat at left served cargo and passenger ships on the river. The many houseboats, some of them turned into permanent housing or lodging, also served more unsavory purposes in early days as well as gambling parlors and such. Riverside Mill is the large white building in the distance. (McCoy.)

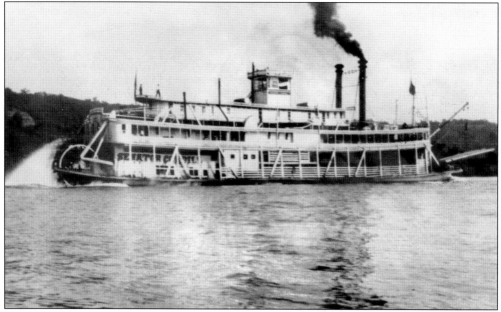

A SUNKEN SENATOR. The stern-wheeler packet *Senator Cordill* was built at Jeffersonville, Indiana, in 1902. Running in the Pittsburgh-Charleston trade, it stopped at the Sistersville wharf boat every trip to handle freight and passengers. On February 5, 1934, it struck an improperly lowered wicket at old U.S. Lock No. 14 above Clarington, Ohio, and sank along the upper guide wall. It was refloated, sold, and dismantled at Sistersville in 1939. (Thistle.)

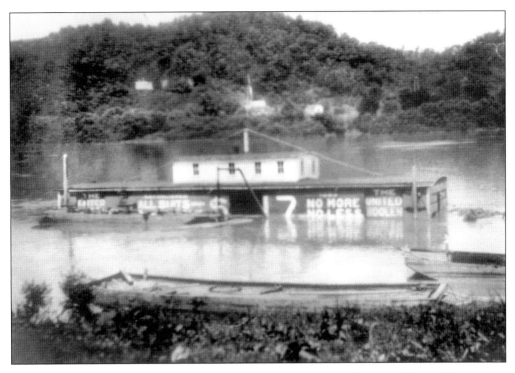

WAYFARING WHARF BOATS. The 1918 wharf boat (above) sank just offshore. Flames were spotted about 2:30 a.m. on January 23, 1936, on Sistersville's last wharf boat (below), which had served since 1920. Only good work by the Sistersville Volunteer Fire Department prevented total destruction. The temperature of -4 degrees caused trouble with the water supply, but the two boats at the left were saved. (Thistle.)

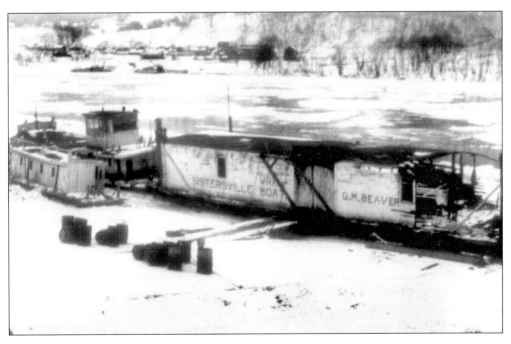

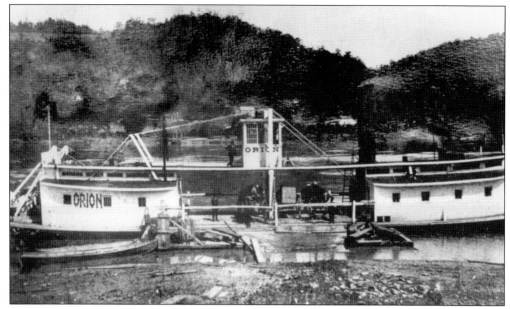

ORION'S GATE. As technology and industry improved, Sistersville's ferryboats progressed and changed in design. Here the steam-powered ferryboat *Orion*, which loaded from the side, is landed at the Sistersville landing in 1902. She operated between Sistersville and Fly until 1907, when she was replaced by a similar boat, the *Daniel*. The *Orion* was built at Belle Vernon, Pennsylvania, in 1884. (Thistle.)

COOL CUSTOMERS. Gentlemen take a short summer trip across the Ohio in a small passenger ferry on the river at Sistersville. They may be crossing to Ohio or taking the ride to Friendly or Paden City; the low canopy near the water's edge and fast vessel keeps a cool breeze blowing on a hot summer day on the river. (McCoy.)

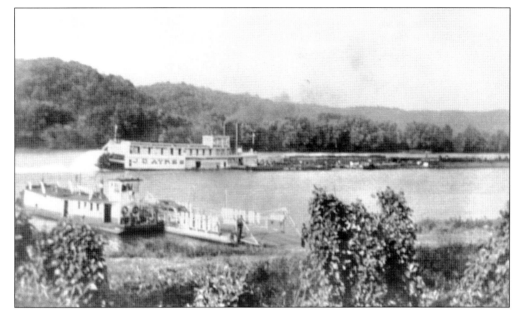

BARGE RIGHT IN. In this early-20th-century scene, the stern-wheeler *J. D. Ayres* heads upriver past Sistersville pushing some heavily loaded barges as the ferryboat prepares to pull away from shore to take a pair of cars to Fly, Ohio. Coal mining has been a major industry in areas north and south of Tyler County but never in the county itself. (Author.)

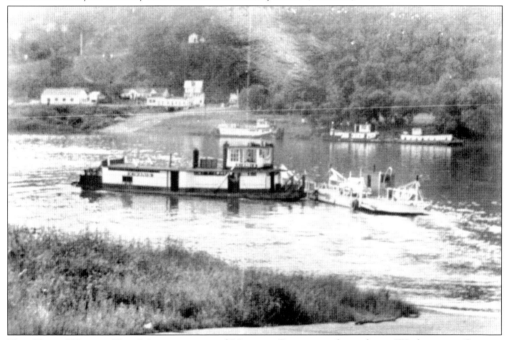

THE EASY WAY TO FLY. Many citizens of Monroe County and northern Washington County have relied on the Sistersville ferry for many years to get them to the nearest shops, hospital, and places of employment in Tyler County. Tyler County is the only Ohio River county in West Virginia that does not have a bridge crossing to Ohio. The two sides of the river share more than the ferry; they also share a common oil boom history. (Author.)

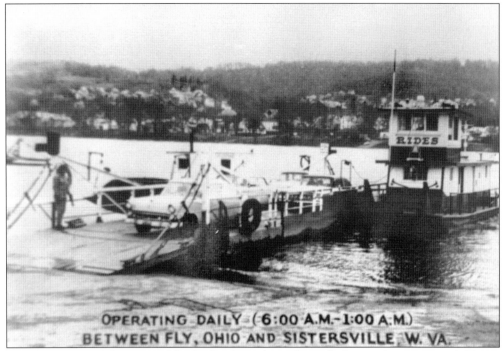

OPERATING DAILY (6:00 A.M.–1:00 A.M.)
BETWEEN FLY, OHIO AND SISTERSVILLE, W. VA.

TRIED AND TRUE. The postcard for the ferryboat above shows the hours of operation as 6:00 a.m. to 1:00 a.m. Hours have been cut back for the latest ferry to travel between Fly and Sistersville, but service continues under the operation of the City of Sistersville. In 2008, the Sistersville Ferry will have operated for 190 years. Henry Jolly was the first operator when the state legislature established the ferry on January 28, 1818. High water has closed the ferry at times, but never low water. The *Little Sister* oil derrick now stands proudly next to the ferry landing on Riverside Drive, a working reminder of the town's proud oil history. The derrick was refurbished through help from the Quaker State Oil Company and is operated each year at the Oil and Gas Festival. (Author.)

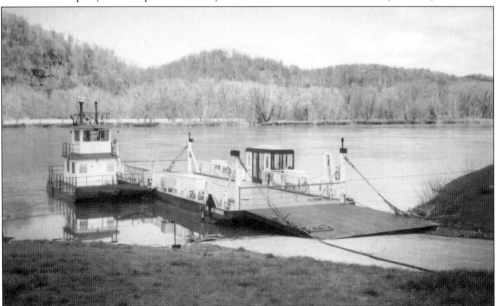

SCENIC RAILROAD. In addition to the B&O Railroad built in 1884, a short-line, narrow-gauge railroad was built for hauling oil drilling supplies over the hills of Tyler County. The crowd of onlookers next to and on top of the belt house may have been part of the locomotive's cargo on this trip. The people do make a good reference for the scale of the oil derrick. (McCoy.)

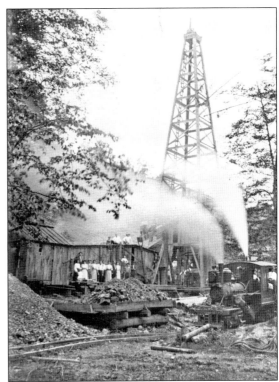

ALL ABOARD. As the oil boom caused a surge of industry and travel in Sistersville and Tyler County, railroad workers were needed to expand train sidings and tracks through town and also in building short lines over the hills toward Middlebourne and Oil Ridge. These workers posing around engine No. 2113 may have just completed a job or are just gathered for a photograph in the B&O yards at the east edge of town. (McCoy.)

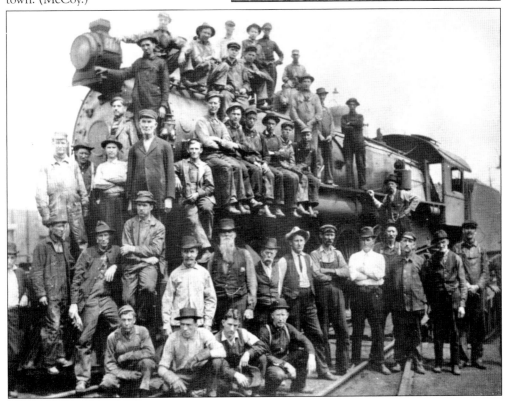

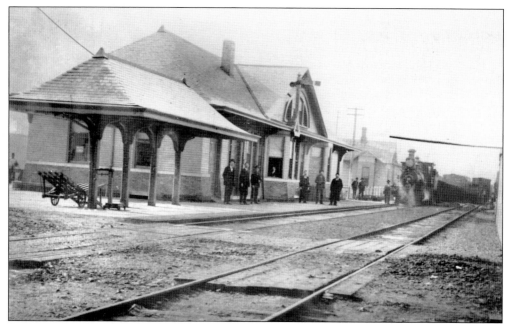

CHOO CHOO ME HOME. Steam locomotive No. 10 has just arrived at the Sistersville B&O Depot near Burt Street with a load of freight from the south. The building was of similar design to those built in New Martinsville and Williamstown, West Virginia. Passengers and freight arrived at the same station, but the covered outdoor platform allowed a dry or shaded waiting area outdoors. (McCoy.)

READY TO ROLL. This Henaghan and Hanlon railcar, freshly painted and used to transport oil and gasoline from Sistersville all over the country, had a capacity of 8,094 gallons. It was built in March 1920 by General American Tank Corporation in Chicago, Illinois, and tested at Warren, Ohio. Companies were given symbols to label their railroad tanks, assigned by the railroads. Henaghan and Hanlon was registered under HHX from 1920 until 1923. (Author.)

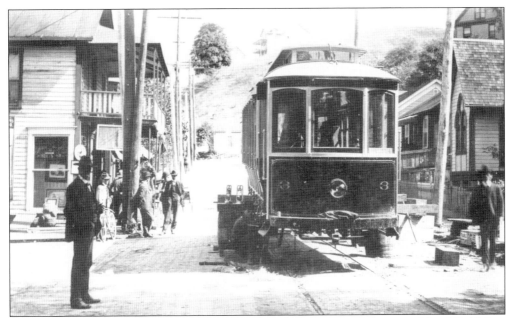

THE NEW NO. 3. The Union Traction Company was carrying out the assembly of Gold Star Route Car No. 3 right in the middle of North Wells Street in front of the Episcopal church. The new car was probably being fitted on an existing undercarriage. The tracks would go to Paden City and then on to New Martinsville. (McCoy.)

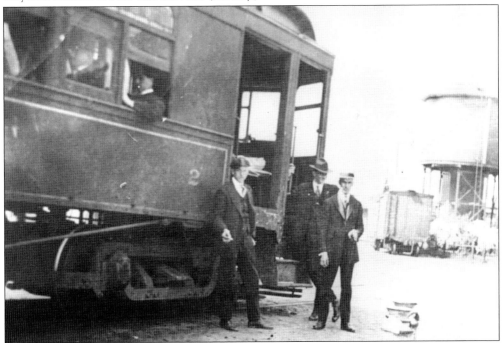

ELECTRIC LUXURY. The trolley cars in Sistersville, including those of the Tyler Traction Company, which operated between Middlebourne and Sistersville after 1917, used electric overhead cables for power. Here we see streetcar No. 2 beside the B&O station, with Ike Baker and Jim Baker and probably a porter (left) waiting for departure to Middlebourne. (Thistle.)

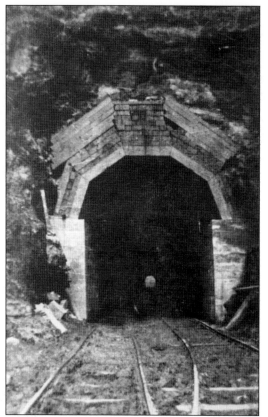

A Light at the End. Passing under Greenwood Cemetery and Old State Route 18, construction is almost finished on the River Hill Tunnel. The Tyler Traction Company had several tunnels, this one wide enough for two cars to pass inside. Passing cars nearly proved deadly once at the B&O Depot. A Tyler Traction car was waiting on a siding to permit another car to pass; as the other was leaving the siding downgrade, a man at the rear of the car failed to get the trolley pole on the overhead line. Ralph Broadwater Sr. was acting as motorman, and as the car gained speed, he applied the air brakes, but they failed, as did hand brakes. The car jumped the track and demolished an oil well supply store. Broadwater was severely injured, but no passengers were on the car. (Left, McCoy; below, Thistle.)

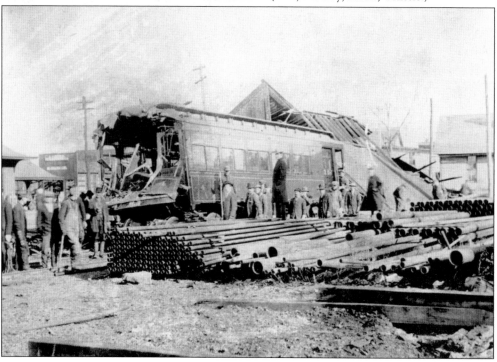

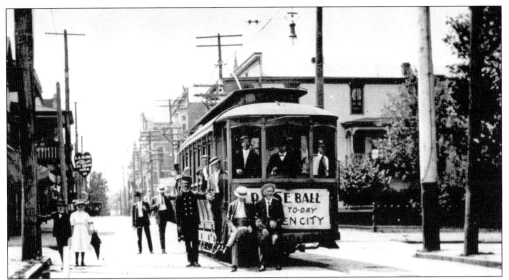

TAKE ME OUT TO THE BALLGAME. This almost fully loaded streetcar is stopped at the intersection of Wells and Elizabeth Streets on the Sistersville–to–New Martinsville line *c.* 1909. Apparently some fans of the national pastime are headed to Paden City to see a baseball game as advertised on the front of the car. (McCoy.)

TAKE STOCK IN IT. The Tyler Traction Company was chartered as a West Virginia corporation on April 10, 1911. The corporation filed a voluntary dissolution on June 23, 1931. The Tyler Traction was an electric railroad that operated from Sistersville to Middlebourne. The electric railroad had track that joined the B&O Railroad behind the B&O depot. The large brick building long occupied by Coca-Cola bottling works originally was the Tyler Traction Company carbarn. (Thistle.)

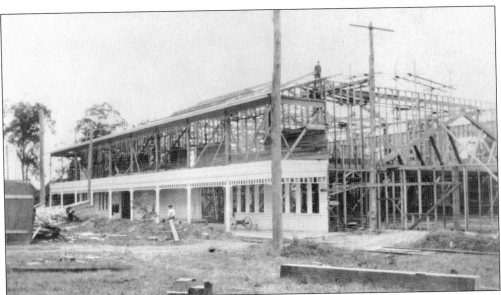

PLACE TO PLAY. In 1904, the Ohio Valley and Duquesne Glass Companies began operations and worked together to increase business exposure. On acres of land in south Paden City, they built Paden Park. A baseball field, open dance floor, small building for storing and selling confections, and merry-go-round space were constructed. In 1909, C. W. Dowling of Marietta began building this pavilion. (McCoy.)

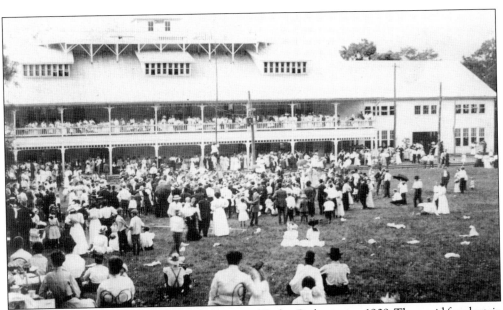

IOOF PICNIC. Union Traction Company operated Paden Park starting 1909. They paid for electric railway improvements and the new building known as Paden Park Pavilion. The first floor was a large dance floor, the second a roller-skating rink, and the top floor a platform for skeet shooting. In 1911, an addition was built on the north end of the building for one of the largest merry-go-rounds in the state. The park closed in 1943. (McCoy.)

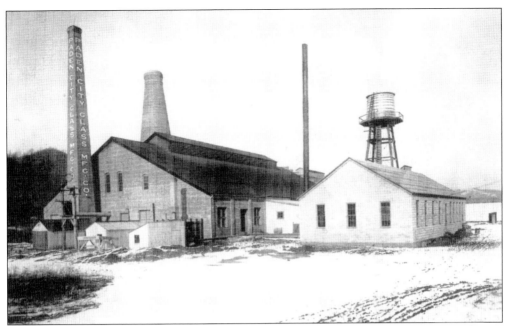

ONCE AND FUTURE KING. Marble King, relocated from St. Mary's to Paden City in 1958, is a leading producer of marbles. The company was cofounded by Berry Pink, who traveled the country promoting and handing out marbles to earn the nickname "the marble king." The company was purchased by Roger Howdyshell and is now run by his daughter Berri Fox. Sistersville hosts Marblefest each September. (Tyler County Museum.)

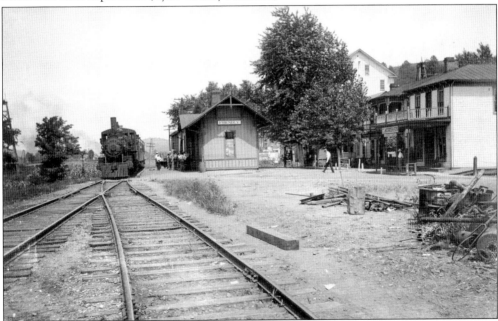

ALL IN THE NAME. This scene shows Friendly Railroad Depot and the Creed L. Morris Hardware and Harness Shop in 1907. Friendly's city building and school are on the National Register of Historic Places. The Williamson family has deep roots here and once ran a gristmill on the river that was dismantled and sold for use in Guysville, Ohio. (Tyler County Museum.)

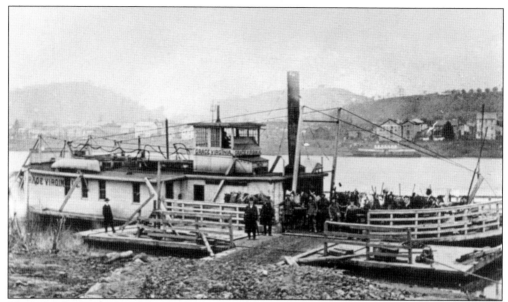

MEXICAN CONNECTION. The ferryboat *Grace Virginia* is seen docked on the West Virginia shore just between Friendly and Davenport, then known as Matamoras Station. The steamship, built in Parkersburg in 1900, ferried people, horses, and goods across the Ohio River to New Matamoras, Ohio. The name Matamoras was taken in honor of that battle during the Mexican-American War. (Tyler County Museum.)

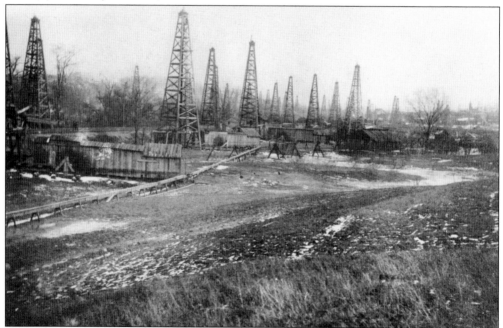

MISTY RIVER BOTTOM. These Ben's Run oil derricks are so numerous they jumble the sky. Ben's Run is at the southern border of Tyler and Pleasants Counties by the Ohio River, where a large flat marsh is created by the run. Ancient cultures left many artifacts here, and today the area is still important for industry with river, road, and rail and the Tyler County Industrial Park. (Tyler County Museum.)

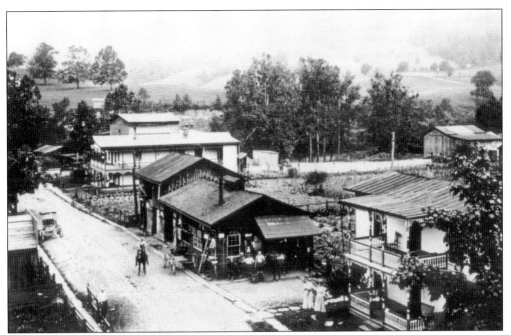

SURE IS PRETTY. This view of Shirley, near the Tyler-Doddridge border, seems unusual for the time because there are no oil derricks immediately visible. The house at the right front with the decorative two-story porch is the Kemper House, the next building up the lane is a blacksmith shop, then the Shirley House, and the last building is the Sweeney House. (Tyler County Museum.)

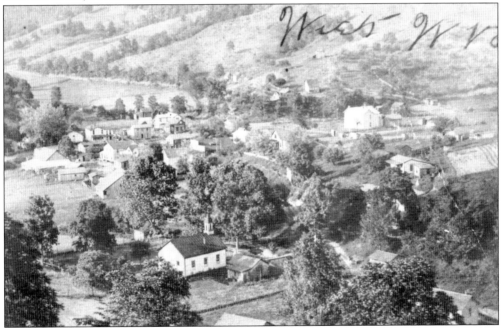

COUNTRY TIME. The small community of Wick was built at the juncture of Sugar Creek and Walnut Run. Before the oil boom, this farming hamlet was one of Tyler County's largest population centers. The Carter Oil Company drilled the largest oil well in Tyler County one mile southeast of Wick on the J. W. Ankrom farm. It flowed 3,500 barrels the first 24 hours. (Tyler County Museum.)

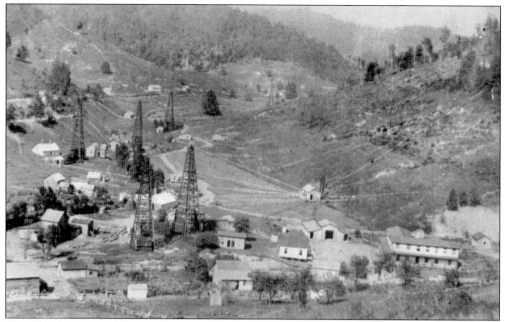

Out Indian Creek. The communities of Big Moses, Booher, Alvy, Braden, and Dale are all strung along Indian Creek in a heavy oil- and gas-producing area of Tyler County, hence the nickname "Stringtown." At one time home to a few thousand people, Alvy was built with boardwalks to go from business to business and house to house up and down the creek. In this picture, a central steam plant was used to pump several wells in the surrounding hills. (McCoy.)

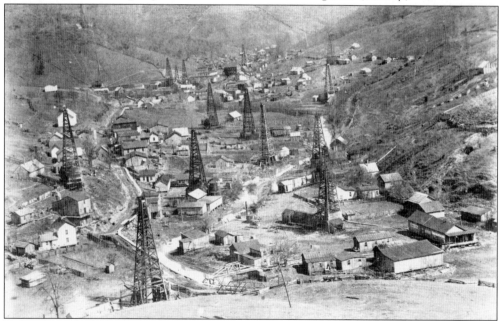

Alma. Founded in 1894 with the oil boom in full swing, Alma grew from a small farming cluster to be the home of over 100 people and at least 16 oil wells, as can be seen here. Also called Centerville at one time, Alma is about two miles east of the Big Moses gas well, in the geographical center of the county. (McCoy.)

106

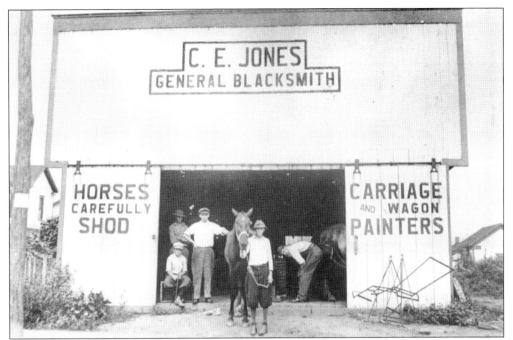

HORSESHOES ANYONE? The C. E. Jones General Blacksmith shop was located on Fair Street in Middlebourne at the longtime location of the local feed store. They offered services for horses and for the wagons and carriages. (Tyler County Museum.)

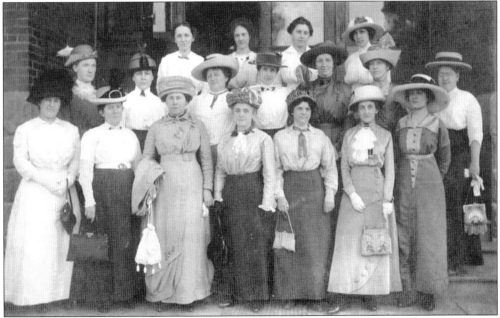

GRAB YOUR HAT. These ladies in front of Tyler County High School on May 2, 1913, are identified in no particular order as Mrs. E. N. Fisher, Mrs. J. G. Wolfe, Mrs. Charles Morrow, Mrs. ? Darnil, Mrs. Charles Lue, Mrs. Louis Lessin, Mrs. Alvin Holmes, Mrs. Frank Keener, Mrs. ? Cumming, Mrs. ? Ackerson, Mrs. ? Hill, Mrs. ? Sharf, Blanche McCoach, Mrs. A. N. Jones, and (in the back) three teachers. (McCoy.)

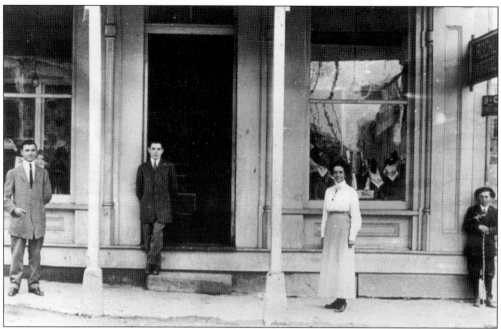

WON'T BE UNDERSOLD. The Rocklin Brothers Store at the corner of Main Street and Broad Street in Middlebourne advertised as undersellers, meaning they would have the lowest prices around. The display in the window features shoes on decorative cloth over wooden stands. (Tyler County Museum.)

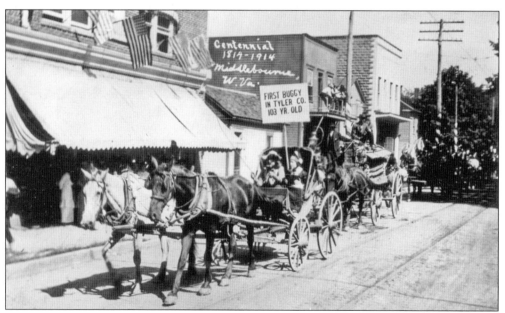

CENTURY OF PROSPERITY. The 1914 Tyler County centennial was celebrated with a parade in Middlebourne among other events. One parade participant was this 1811 buggy with a sign claiming to be the oldest in the county at 103 years old. Notice the streetcar tracks along Main Street; this was the route that the trolley took to and from Sistersville. In 1993, Main, East, and Dodd Streets were declared the Middlebourne National Historic District. (Tyler County Museum.)

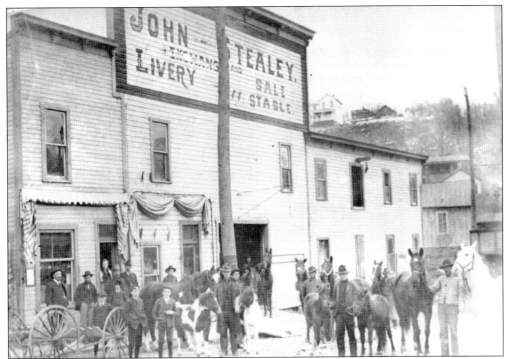

SADDLE UP. John Stealey's Livery and Sale Stable was located on Charles Street, where the Elks Annex is today. The barn had stalls for more than 35 horses. Stealey had the contract for hauling (Star Route) U.S. mail between Sistersville and Middlebourne. Mose Bowman bought the business from Stealey, and later Mike Brady bought it from Bowman. The barn burned while owned by Brady. (McCoy.)

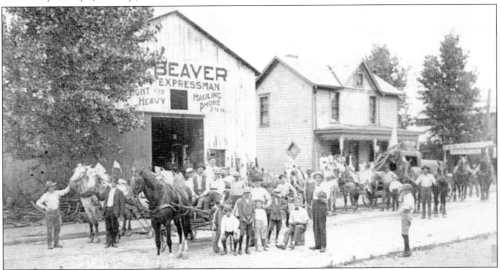

OUT WITH THE OLD. This might have been a parade day for the Beaver Expressman teams judging by the flags on their harnesses, but business for such draft-horse teams would be harder and harder to maintain with the advancement of the automobile. Sistersville's gasoline refineries helped to advance the auto age nationwide, meaning an approaching end to the town's horse-and-buggy days. (Vincent.)

FILL HER UP. The oil interests in town along with the increasing demand for availability of gasoline led to the opening of several gas and service stations around Sistersville. The first Karl's Esso service station, the branding name of Standard Oil (S.O.), was located at the southeast corner of Diamond and Chelsea Streets in 1933. (Thistle.)

TAKE TO THE STREETS. The Tyler Motor Company, owned by Lucien Talbott in 1914, was the first garage in Sistersville and may have been the first in Tyler County. Talbott was agent for Overland and Pullman automobiles. This car is an Overland Model 75 four-cylinder with electric starter, electric lights, and leather upholstering; it sold for $1,075. From left to right are unidentified, Lucien Talbott, C. E. McCoy, Evart Thistle, and Sam Hubbard. (Thistle.)

Six

REFINERIES, FACTORIES, FIRES, AND FLOODS

J. T. JONES HOSE COMPANY. Hose companies in the 1890s were part fraternity, part pageantry, and very important to fire protection in Sistersville, where houses nearly touched and wooden homes stood in close proximity to oil derricks and machinery. The J. T. Jones Hose Company had a prominent location on the diamond where the City Building stands but built a larger hose house on Brown Betty Street. Capt. Joseph T. Jones also owned an oil company and had rights to 92 wells on 1,110 acres on each side of the river. The millions he made were spent to build the Gulf and Ship Island Railroad and the city and harbor of Gulfport, Mississippi, where his bronze likeness stands by the waterfront. (McCoy.)

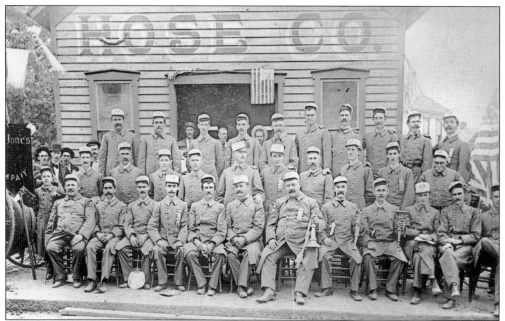

FIRE PROOF. The gentlemen of the J. T. Jones Hose Company are seen posing for an 1895 company photograph, possibly prior to marching in a parade, as evidenced by the young boy holding the banner at the far left. Several of the men in front are holding hose nozzles and other tools of the firefighting trade. (McCoy.)

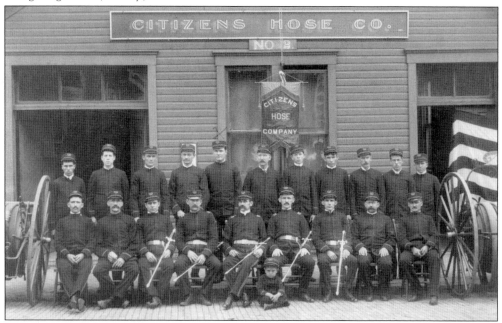

RAPID RESPONSE. The Citizens Hose Company poses in front of one of their two hose houses in full dress, with carts of fiber hoses at each end and their "mascot" at their feet. From the early days of bucket brigades, firefighters have increasingly used new technology to fight fires and keep communities safe. Sistersville, Middlebourne, and surrounding areas of Tyler County employ well-trained volunteer forces of firemen. (McCoy.)

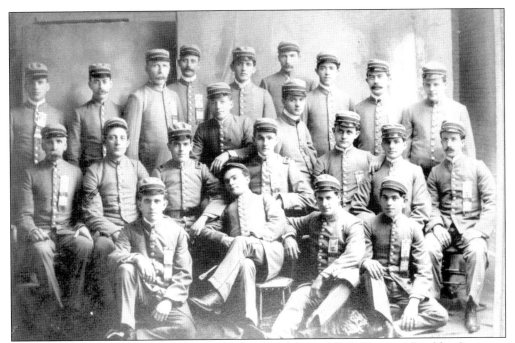

EPHRAIM WELLS HOSE COMPANY. Members of the Ephraim Wells Hook and Ladder Company posed for this group portrait in Sistersville about 1900. They are wearing their best dress uniforms, the ones they would use in parades and ceremonies. Notice the military caps, tasseled lapel ribbons, brass buttons, and decorative belt buckles. The pageantry and notoriety of belonging to a hose company encouraged membership of various ages. (McCoy.)

CAMERA SHY. This pretty young unidentified girl is front and center with dark eyes locked on the camera and hands retracted as though she just stepped into the shot. However, in her gleaming white dress, sharp hat, and shiny bracelet, she mirrors the pageantry of the Ephraim Wells Hook and Ladder Company standing in rest formation behind her. Firemen have been a staple in Sistersville parades since the 19th century. (McCoy.)

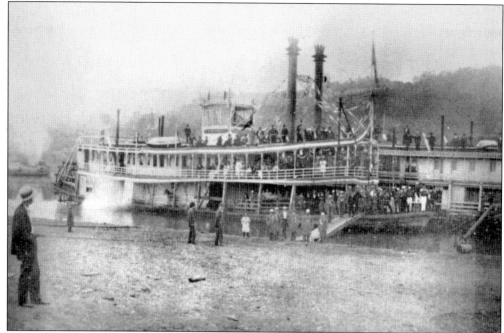

SISTERSVILLE PRIDE. The Ephraim Wells, J. T. Jones, and Citizens Hose Company members are boarding the *T. N. Barnsdall* to compete in hose laying, water throwing, and life-saving skills in Bellaire, Ohio. While the firemen in Sistersville jockeyed for position among themselves, when facing competition from outside the state or community, they stuck together. (Vincent.)

SUMMER SPLASH. For practice and fun, local firemen would hold games with water hoses during the summer months. The hose company fight on July 4, 1908, in Sistersville drew quite a crowd, some hoping to be cooled off, others entertained by the firemen being doused with high pressure. The Oil and Gas Festival has featured fire hose contests in the past. (Vincent.)

SMOKE OUT. Though it was still dangerous, people of the time seemed to crowd around a fire to get the best seat. The J. T. Jones Hose Company responded to this June 1896 fire on the west side the 600 block of Wells Street. Their technique was to empty the home or business of flammables and valuables to reduce potential fuel as well as greater property loss, and then extinguish the flames. (Vincent.)

EXTINGUISHERS. The J. T. Jones Volunteer Hose Company has just put out a fire in the White Front Saloon on the west side of Wells Street, as seen in the picture above. Charles Bailey, saloon owner, is the man wearing the raincoat at the left, and P. C. Ackerson is at the extreme right. The Jones Company saved these buildings in 1896, and they stood until another fire in 1982. (Thistle.)

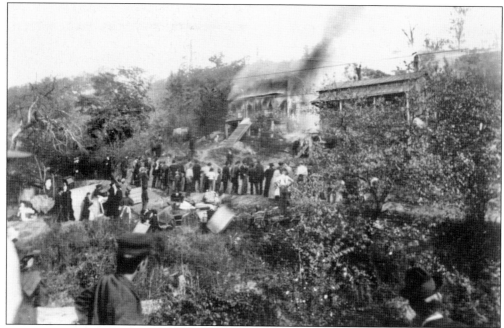

OIL SHACK FIRE. When an oil shack caught on fire, it was like a bomb went off. These buildings were typically built in one day for a cost of around $500 with hemlock board walls covered in unbleached muslin and wallpaper pasted on top. This cheap housing was satisfactory because there weren't many options for housing and most newcomers figured the oil would be gone in a year or so. (McCoy.)

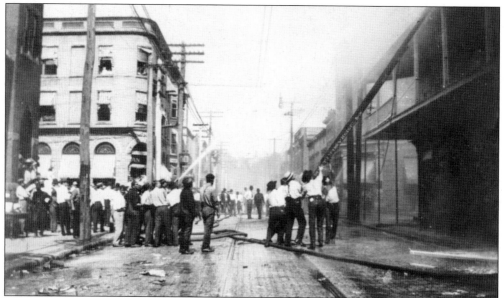

SAD GOODBYE. The Ephraim Wells Hose Company is seen here fighting the fire at the saloon on August 23, 1909. The building at the corner of Diamond and Wells Streets was originally built as the Olston Opera and later was called the Olston, the Hosford, and the Mercer Hotels. The broad second-story porch served as a favorite perch for hotel guests and people taking in other events on Wells Street. (McCoy.)

UP IN SMOKE. Crowds gathered to watch the burning of the saloon on August 23, 1909. The building was built around 1892 and had served many purposes and had many names in 17 years. Businesses that had been on the first floor, such as the Knapp and McMullin confectionery and paper shop, were forced to relocate. (McCoy.)

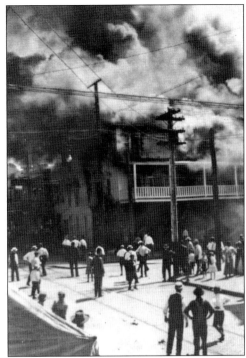

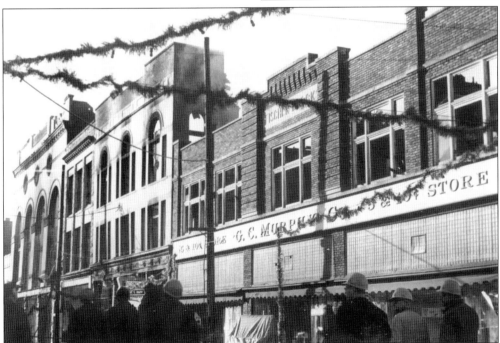

DARK DECEMBER. The tragic fire of December 8, 1970, destroyed (from left to right) the opera house with Starcher's Hardware on the first floor, Shiben's Department Store, the Wells Building with the Hope Natural Gas Company Office on the first floor, and the G. C. Murphy Store located in the Fischer Block building. In the aftermath, Christmas garland added an eerie feeling to a downtown that would never be the same. (Thistle.)

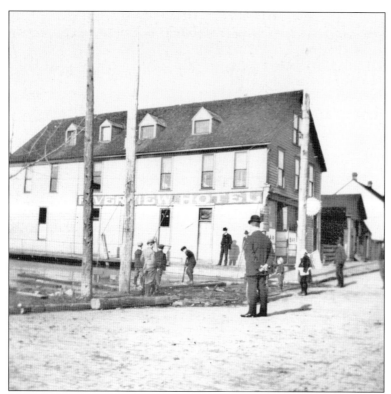

RIVERVIEW HOTEL. Boys poke through the debris brought to the edge of Water Street by the 1904 spring rise of the Ohio. The Riverview Hotel, built by W. P. Bowman at the end of Charles Street and later run by Jim Chambers, had water up to the second story during many floods. The first floor housed a saloon with rooms upstairs overlooking the river. (McCoy.)

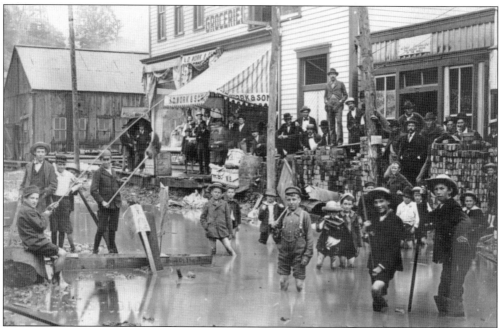

MAID OF THE MUD. Heavy rains are responsible for these muddy conditions that attracted a crowd of young boys. The boy with the pole at left has cast his line to "fish," and the small wooden boat at his feet is christened the *Maid of the Mud*. Several men in front of A. D. Work and Sons and the adjacent building are standing near the bricks that will pave Diamond Street. (McCoy.)

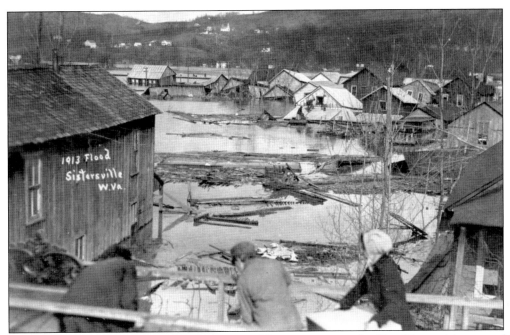

DEEP TROUBLE. The big flood of 1913 was one of the worst ever on the Ohio River, with crests of 51.5 feet at Wheeling and 69.9 feet at Cincinnati. This photograph was taken from the railroad tracks looking over the space currently occupied by Dairy Queen. Note the woman in the boat and two people on the white roof of the McCoy Street house at center. (Thistle.)

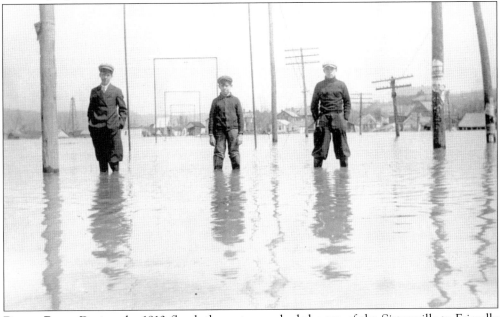

BRAVE BOYS. During the 1913 flood, the water reached the top of the Sistersville-to-Friendly streetcar trestle that crossed Tanyard Run and the current city park. With the floodwaters below the trestle reaching a depth of 20 or more feet, and the power cable for the streetcar running overhead, Art Carol (left), John McCamey (center), and an unidentified boy are on dangerous ground. (Thistle.)

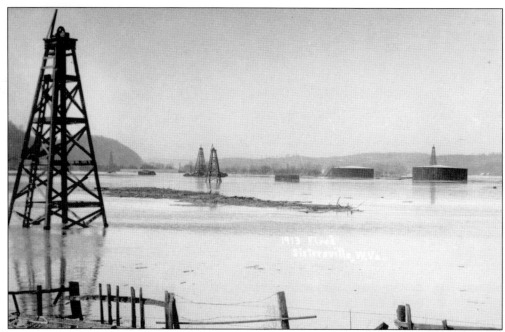

WELLS ISLAND. The March 1913 flood covered the Ephraim Wells farm, as seen from the yard of the Welkin estate. Just to the left of the large tanks would be the site of the Sistersville Country Club house in 1925. The trees behind the tanks are on Wells Island, home of several very productive oil wells for the Fisher Oil Company. (Thistle.)

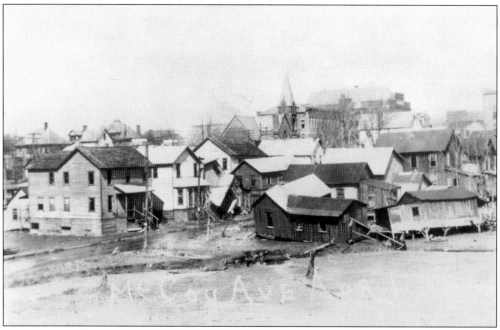

AFTERMATH. The 1913 floodwaters have receded to reveal a high extent of damage and destruction to these McCoy Street houses on April 1, 1913. The stream in the foreground is Tanyard Run, which flows from Happy Hollow. James Jolly established the first tanning mill in the area at Tanyard Run. (Thistle.)

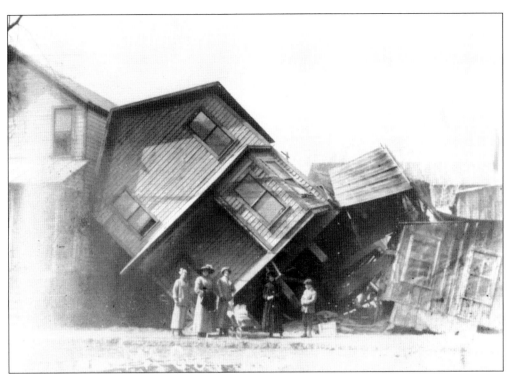

UPROOTED. Four ladies and a young man, all dressed in finery and complete with a baby carriage, pose in stark contrast to the jumble of destruction caused by the powerful floodwaters of the Ohio River. Homes on McCoy Street and many others in the lower elevations of Sistersville were moved from their foundations and simply floated about or crushed during the 1913 flood. (Thistle.)

BRAVE SOULS. These ironworkers are raising the smokestacks at the Independent Glass Company near the present site of Sistersville Tank Works. The B&O railroad tracks with a siding, as well as the trolley tracks, lie in the foreground, and a huge bale to cord is at right. An overpass to carry State Route 2 traffic over the railroad would be built at right in later years. (Author.)

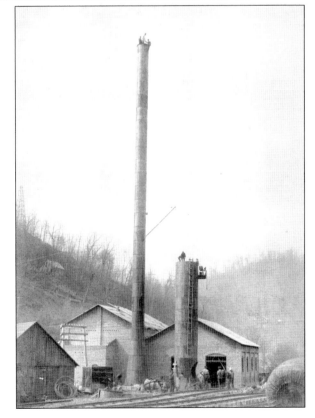

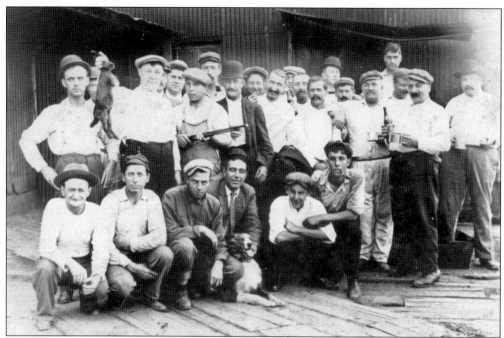

MELTING POT. These Independent Glass Company employees are probably "off the clock." The gentleman at left holds a rabbit, presumably shot by the fellow holding the gun, while two men at right are enjoying a drink. Sistersville's population peaked around 1895, but immigrants continued to arrive to open shops, build tanks, make glass or steel, or enter any other satellite industry that supported oil and the economy. (McCoy.)

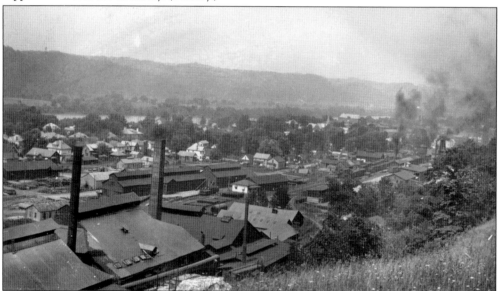

CITY AT WORK. The Carter Oil Works grew so much over time that it had to build the bull wheels and molds it needed in woodworking shops and make castings for rig parts, fittings, and tools in its own iron and steel foundry. Despite the industry, Sistersville was a very clean town because of the availability of natural gas for heating. Glass plants also came for the cheap, clean fuel. (McCoy.)

BRAINS. The 1918 Carter Oil Company office force at Welkin is, from left to right, (seated) W. H. Cooper, Joe Dawson, Joseph Sidwell, Tom Mobley, J. D. Case, and A. H. Salisbury; (standing) ? Perry, unidentified, Mary Fox, ? Reynolds, ? Fox, Cecil Cutler, Levi Rawson, Harry "Bud" Stoops, Mae Corbitt, Jack Fitzgerald, Louis Case, unidentified, Jimmy O'Brien, Gale Poole, Charles Decker, ? Scott, Leo Horty, ? Ellis, and Tom Twowy. (Thistle.)

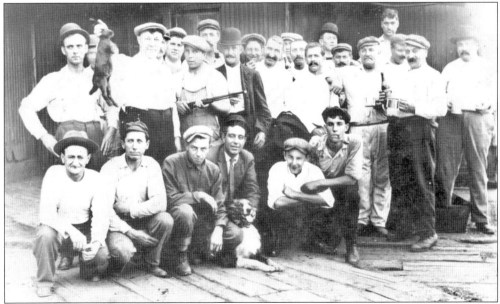

BRAWN. The 1917 Carter Oil Company machine shop crew is, from left to right, (seated) Elsworth Deweese, Lou Ridgeway, Lou Chadderdon, Lou Case, and Joey Fulmer; (standing) Lee Case, Clyde Kellar, Lee Herbold, Ernest "Runt" Cutler, Clarence White-Spencer, Art Case, Walt Arnold, Sam Baker, Frank Stewart, Ollie Smyther, and Bill Gregg. (McCoy.)

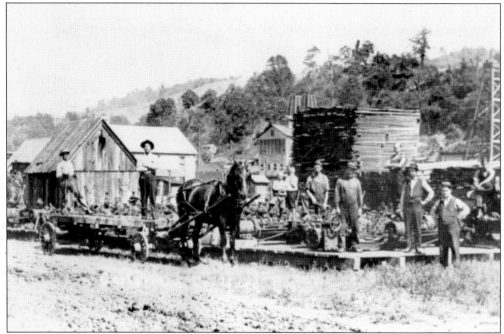

HORSEPOWER. The Carter Oil Company yard crew at this time were, from left to right, Gill Collins, who drove the big horse Jack; Russ Beaver, on the front of the wagon; two unidentified boys; Lou Boyer; Mike Kelly; unidentified; C. W. "Red" Hubbard, the yard boss; Tom Lanean; and Arch Boyd. Note the steam engines on the platform and the large stacks of lumber. The Sistersville Ice Plant is in the background. (Thistle.)

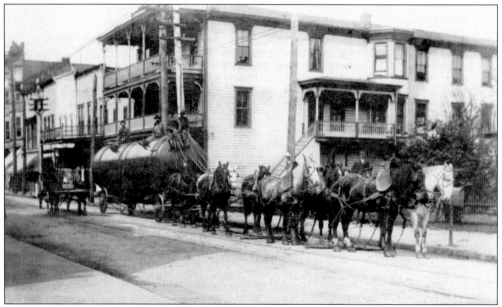

TANK COMMANDERS. In 1911, the first Carter Oil–Cox Gasoline Plant storage tank waits in front of the Arlington Hotel on its way to the old Sam Cox Farm on Oil Ridge. W. H. "Doc" Railing and "Big" Bill Hall are driving the teams with Andy Clay and Nate Barr on the tank. It would take four teams of strong horses to pull the heavy tank up the steep hills from town. (Thistle.)

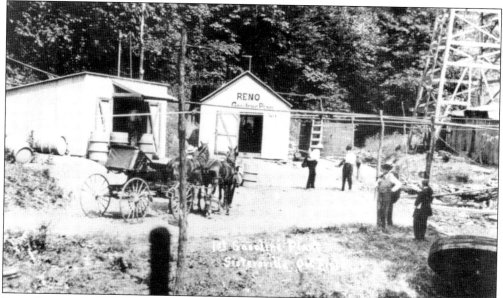

RENO PLANT. The Reno Gasoline Plant was the first in the Sistersville Oil Field. This process was one of the most important developments to come out of Sistersville. Gasoline was naturally created by the reduction of pressure at the well casing head, but demand rose quickly. Manufacturing gasoline was done by heating oil and then condensing it, early on with a cool mountain stream, later with a compressor plant. (Thistle.)

WORLD'S BIGGEST. In 1911, the Anshutz plant, the largest gasoline plant in the world, was built by Carter Oil south of Sistersville on Route 2 near Davenport. These workers are in a compressor plant. After a cooling process, the condensed oil vapors form gasoline, which is likely what this man's glass container holds. W. L. Sutton of Sistersville was cited by the American Petroleum Institute in 1925 for his gasoline development work. (Thistle.)

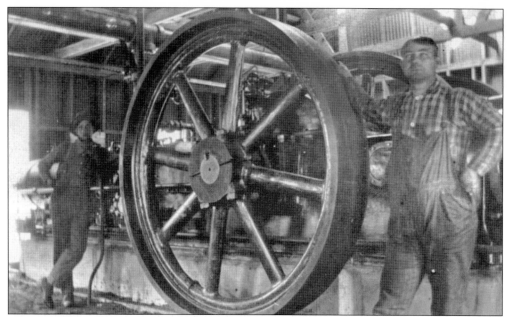

COOKING WITH GAS. The large central steam plants used to power several derricks at once in the early years were eventually replaced with gasoline engines that were more efficient. The gas engine turned a generator, which created electricity so that wires instead of hissing steam could be directed to pumps at the well sites. (Vincent.)

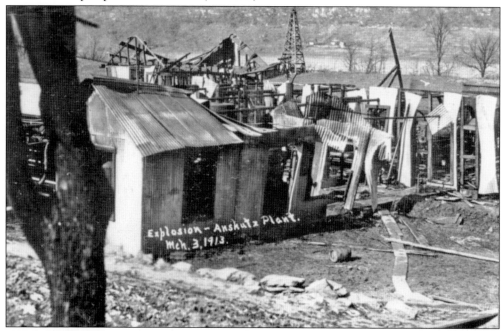

DELICATE OPERATION. On March 3, 1913, there was a large explosion at the Anshutz plant. Early gasoline was quite unstable, as propane industry founder Andy Kerr once explained in *Butane-Propane News*: "The gasoline obtained from these plants was an ornery, dangerous product." Kerr learned how to separate butane and propane from gasoline in Sistersville and went on to found American Gasol in 1911 and, in 1925, California's Imperial Gas Company. (Thistle.)

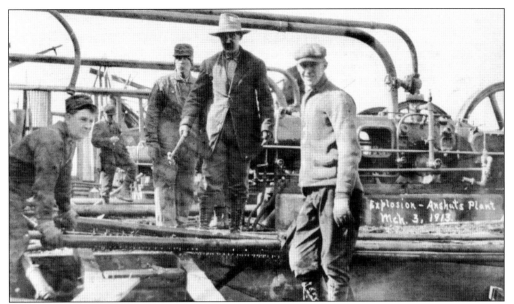

REBUILDING. After the 1913 explosion at the Carter Oil Company's Anshutz Gasoline Plant, workers Bill Quigley (left), Dent Wilkinson (with the hammer), and Royal Kepner (right) work to clear out debris and clean up the facility. Contrary to published reports, the plant was rebuilt and continued to operate until the 1930s. One small building and the concrete foundations for the cooling tanks are all that remain today. (Thistle.)

Wells Street, Sistersville, West Virginia

WELCOME HOME. This is how Wells Street looked from the 1920s until 1969, when the first Oil and Gas Festival was held on the city streets. The annual event now draws crowds of over 20,000 to City Park each September to see gas engines, oil field tools, art displays, and of course the Grand Parade. Visitors will recognize many of the buildings and locations in this book and experience the charming legacy of the oil boom just by walking the streets of Sistersville. (Tyler County Museum.)

ACROSS AMERICA, PEOPLE ARE DISCOVERING SOMETHING WONDERFUL. THEIR HERITAGE.

Arcadia Publishing is the leading local history publisher in the United States. With more than 3,000 titles in print and hundreds of new titles released every year, Arcadia has extensive specialized experience chronicling the history of communities and celebrating America's hidden stories, bringing to life the people, places, and events from the past. To discover the history of other communities across the nation, please visit:

www.arcadiapublishing.com

Customized search tools allow you to find regional history books about the town where you grew up, the cities where your friends and family live, the town where your parents met, or even that retirement spot you've been dreaming about.